D1499010

# A POT
# OF PAINT

TO JACQUES-EMILE BLANCHE
AND BERNHARD BERENSON
IN MEMORY OF TWO SUMMERS

# A POT OF PAINT
## THE ARTISTS OF THE 1890's

*By*

JOHN K. M. ROTHENSTEIN

" *A pot of paint flung into the face of the public.*"—Ruskin.

*Essay Index Reprint Series*

## BOOKS FOR LIBRARIES PRESS
### FREEPORT, NEW YORK

First Published 1929
Reprinted 1970

*759.2*

*R846p*

*N6767*
*.R55*
*1970*

INTERNATIONAL STANDARD BOOK NUMBER:
0-8369-1847-9

LIBRARY OF CONGRESS CATALOG CARD NUMBER:
70-128303

PRINTED IN THE UNITED STATES OF AMERICA

PLATE I

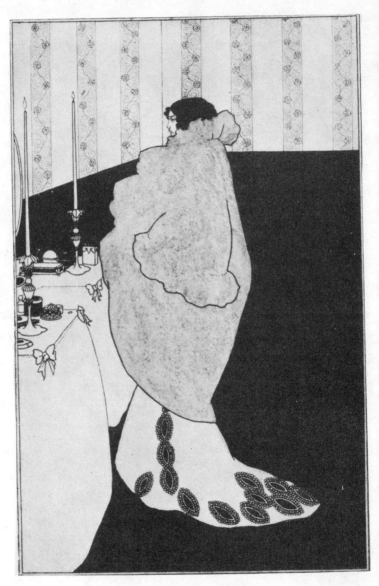

DAME AUX CAMELIAS

*Beardsley*

*In the collection of Mr. Harry Melvill*

[ *from*

# CONTENTS

## PART I:  THE SETTING

## PART II:  THE PLAYERS

# LIST OF ILLUSTRATIONS

# PART I
# THE SETTING

# Chapter One

## *The Artist and the Industrial World*

IT has always been asserted, and rightly, that the spectator sees more of the game than the participants : that the reader of history endowed with a sense of values sees more than the historian is no less true. Such a reader discerns in history the evolution of mankind—painful, slow and infinitely complex, upon a swiftly spinning and cooling globe, a mere speck in the immensity of the heavens. He sees that the stages of this process of evolution succeed each other as certainly and as inevitably as do the hours. He sees above everything that all existence is one.

Very different is the vision of history seen by the average historian. His is, all unconsciously, the outlook of the advertiser. He is for ever losing sight of the unity and inevitability of all things and forever attempting to foist upon his readers some mere preference of his own for some race, empire, party or reigning house ; as though any of them were separable from the entirety of the fabric of history, save by the employment of a terminology too crude to retain any contact with reality. Some of them spend a lifetime asserting the superiority

3

of one age over another ; as though any age has its being separately from any other. As well spend a lifetime asserting the superiority of three o'clock in the afternoon over eleven o'clock in the morning. At certain times there is greater prosperity, greater learning and less war than at others, but the expression of a personal predilection for certain conditions is not the rightful function of a historian. Yet such is the aim of most of them. Poor sublime Clio, misunderstood by her legitimate spouses, is forced to smile upon the advances of those amateurs who cast upon her their lustful gaze !

Few movements of our own time have been more partially chronicled than that of which we have now to consider the graphic aspect. It has been variously pronounced " great ", " decadent ", " progressive ", " fin-de-siècle ", " minor ", a host of other things, by various authorities who, after pronouncing, have merely rationalised their own view. While it is still too early to make that definite pronouncement upon its merits so dear to the heart of the professional chronicler, we are now sufficiently removed from it to discern with a certain degree of clarity what its essential nature was, some of the influences which moulded it, and the outstanding merits and demerits of the work of its dominant personalities.

At the moment to admire the movement which has become known to us as the 'nineties is highly unfashionable. Even at those two ancient universities where the intelligent minority has for so long kept green the memory

## The Industrial World

of it with the languid enthusiasm of æsthetic youth, a change has come. Now from fashionable undergraduate walls are banished Burne-Jones's dreamy scenes, Beardsley's *Rape of the Lock* and *Salome*, and the ubiquitous Japanese print. In their places hang reproductions of water-colours by Matisse, pastels by Renoir, etchings by Picasso. Gone, too, from their bookshelves are Mallarmé, Baudelaire, Wilde, and Pater, who have given place to Freud, Jung, Joyce, and Chekhov. Black wooden sculpture from Africa has replaced blue china from Cathay. The young man who but yesterday recited " Non sum qualis eram bonae sub regno Cynarae " to an approving group of the elect, to-day would cause them to raise their eyebrows in tribute to his temerity. And if the old affectations remain, they are dropped more quickly than before in the face of the outside world.

But the reaction against the 'nineties is something more than a mere change in taste. Each of its stigmata serves to increase a certain prejudice against it which is inherent in the age. Its strident challenge to the conventions appears to us unnecessary : its individualism cannot seem otherwise than preposterous to a generation which crushing economic pressure and greater knowledge of Eastern philosophy is making increasingly collectivist in outlook. Its love of art " for art's sake " alone we regard as coldly as did Milton "a cloistered virtue ", as something irrelevant to life as a whole.

The first aim of this essay is to show how naturally, how logically the movement of the 'nineties, with all

5

its challenging affectation and extravagance, takes its place in the tradition of art in England ; to show that the very qualities with which we find it difficult to sympathise were rendered inevitable and necessary by circumstances. The second, to examine the essential characteristics of those artists who played their part in it, whose work appears to me to merit the most serious consideration.

The spirit of the eighteen-nineties was in its entirety one of revolt. But so much has been made of its spectacular demonstration against the hypocrisy and dreariness which produced mid-victorian convention-ality, that the true tyrants which it sought to overthrow and the profound nature of its attack have been alike obscured. The objects of its reaction were a new colossus and an ancient octopus : industrialism and classicism. The one was making men slaves to machines, the other for many generations had had a strangle-hold upon the art academies of Europe. Whether or no the rebels saw clearly the objects of their revolt matters not at all ; indeed, it is unlikely that many of them did. Just as a crowd develops loves and hatreds which not one member of it may fully share, so a movement, once launched, develops a personality, aims, and above all a tendency to move in a certain direction entirely different from the individual intentions of its originators and participants. They often become hostile when its ultimate nature reveals itself : more often they simply remain in ignorance of what this is.

6

# The Industrial World

Among the thousands of honest peasants and townsmen who throughout the sixteenth century supported the reforming party, how many realised what they were doing? How many would have persisted in giving their approbation to what appeared to them a necessary reform of abuses, a just curtailment of the power of the Papacy to sacrifice the welfare of England, to the exigencies of continental politics, and the humbling of some of the great ecclesiastics whose excessive wealth and arrogance were alike intolerable—had they seen that they were in fact destroying the unity of Christendom, cutting themselves away from that Catholic Church to which the great majority of them were devotedly attached, and substituting for the successor of St. Peter the successor of William the Conqueror? To discern amidst the noise and dust of the struggle the real nature of the issue a vision of exceptional clarity was needed. Sir Thomas More, the possessor of such a vision, was led to his martyrdom as much by that quality as by his courage, for there were many who, had they had eyes to see, would have had the devotion to die. In truth the ordinary man was as little capable of seeing these things as were those small lawyers, eager to extend their privileges, those enlightened gentlemen and eager doctrinaire reformers who formed the States-General in those fateful May days in 1789—of forseeing, much less acquiescing in, the execution of their king and queen, the terror and the anarchy towards which they were contributing so powerfully.

7

# The Artist

If the men of the 'nineties occasionally scoffed at the octopus, the colossus was hidden from the view of most of them, although the declamations of William Morris had made a whole generation aware of some of the consequences of its dominion. It remained for one who was living in the 'nineties, but who was not of the group to which that decade has given its name, to realise that the colossus was the genius, not the enemy, of the age. When Bernard Shaw asserted that "in all my plays economic studies have played as important a part as a knowledge of anatomy does in the work of Michelangelo", he said something illuminatingly true about his own work and profoundly relevant to all modern art. Since Shaw is above all things an intellectual artist—in fact, the supreme intellectual artist of our time—that which is consciously present in his own work is likely to be latent in that of others. The influence of industrialism, the dominating factor in modern civilisation, upon art is necessarily ever present, whether it happens to be recognised or not by the artist.

Incidentally, it is precisely this element of sympathetic awareness of industrialism which has enabled Shaw, H. G. Wells, and Arnold Bennett to keep such sensitive hands upon the pulse of their age, and excluded them from a movement so fundamentally reactionary as the 'nineties. These men brought eagerly into their art all the branches of science relevant to their constant theme: the present and future of civilisation. If it fulfilled this condition there was no subject before

8

which they recoiled. Art, " for its own sake ", was not
their concern. Closely in touch with the world which
gave it birth their art served a purpose : to help the age
towards self-realisation, towards a truer sense of values
by which to judge the present and mould the future.
The moſt searching literary critic of a later decade,
Virginia Woolf, goes so far as to describe Wells as
" . . . from sheer goodness of heart taking upon his
shoulders the work that ought to have been done by
government officials. . . . "

The indifference of these writers towards the central
tenet of the faith of the 'nineties, that the perfection
of form is virtue, did not make them less good artiſts.
At any rate not in our eyes ; for to us suitability of form
is virtue, and matter and ſtyle are becoming one. Per-
fection meant too often to the followers of Théophile
Gautier the imposition of a form in itself beautiful (in
as far as form in art can exiſt alone) upon a subject
matter with which it does not harmonise. The opening
passage of *The Picture of Dorian Gray* is with its
melodious cadences a perfect example of harmony
between form and matter—" The ſtudio was filled with
the rich odour of roses, and when the light summer wind
ſtirred amidſt the trees of the garden, there came
through the open door the heavy scent of the lilac,
or the more delicate perfume of the pink-flowering
thorn." Yet what could be more grotesque than
the use of such a form for describing a blaſt-furnace,
a crowd watching a a football match, a department-ſtore,

9

or indeed any of the characteristic phenomena of to-day?

Major art should be able to grapple with any manifestation of human activity. Any conception of style which limits that power is necessarily injurious. The men of the 'nineties, therefore, were unconsciously aware of this and unconsciously hostile to a civilisation which brought with it so much with which their conception of beauty and style prevented their having artistic contact. This is the cause of the constant tendency of the men of the 'nineties, during the few crowded years while the spell lasted, towards what was minor in art.

While this is especially true of the period which we are now considering, artists in England have in the decades which followed done little towards the formation of a style which will allow them to come to grips with the subject matter most worth portraying by a vital art —the world in which they live. What seems crystal clear to the most casual student of the arts is to the average modern artist an intolerable heresy. True, living in the twentieth century he cannot paint from life, the nineteenth, the eighteenth or the seventeenth. But he does his best. By hurrying to the least populated parts of our island he seeks out survivals of the past, the exceptional, the picturesque. Wherever there are backward inhabitants, decayed dwellings becoming more decayed for lack of workmen who understand the methods by which such antiquated buildings can be repaired,

bad communications and bad drainage, there, too, the
artist finds his home, an exile from those places where
for good or for ill the great issues before his race are
being perpetually decided and presented again in
different forms. In a study singularly bold and un-
trammelled in spirit, though somewhat harsh in ex-
pression, a modern scientist[1] has condemned the modern
artist :

> I think that the blame for the decay of certain arts rests
> primarily on the defective education of the artists. An artist
> must understand his subject matter. At present not a single
> competent poet and very few painters and etchers outside
> the Glasgow School understand industrial life. . . . Not until
> our poets are once more drawn from the educated classes (I
> speak as a scientist), will they appeal to the average man by
> showing him the beauty in his own life as Homer and Virgil
> appealed to the street urchins who scrawled their verses on the
> walls of Pompeii.

This condemnation has from the scientific point of
view a definite if limited justification. To decide
whether the artist by his flight from modern civilisation
is more or less to blame than the repulsive aspect of the
society that has driven him forth, lies outside the scope
of this essay. Indeed, such questions, continually raised,
have little meaning ; for human beings have so little
power over their circumstances and so much over their
conduct that an attempt at such wholesale attribution
of right and wrong must necessarily be irrelevant. The

[1] *Daedalus, or Science and the Future*, by J. B. S. Haldane.

greater part of justice lies in the consideration of the individual case, the lesser in the formulated general principle. But what the writer hopes to show is the inevitability of the loss of contact between art and the rest of human activities, rather than the morality or the immorality of such a schism. To this end it will be necessary to sketch a brief outline of that greatest of all revolutions, which has increased a hundredfold the pace of history, given to mankind a control over the forces of nature to a degree undreamed before it, and to his affairs a complexity the consideration of which appals the greatest minds.

Between the occupation of Britain by the Romans and the accession of George III every factor which goes towards the making of history had undergone great changes, but so slowly had this happened that at any given moments such changes were almost unappreciable by contemporaries. All times appeared to them static in essentials, changing only in accidentals. It was as though the course of history described a curve so vast as to seem to one who examined a small section of its circumference a line deviating neither to the right nor to the left. To-day the span of human life has not substantially increased, yet in the small section which each one sees he can discern the curve, clearly and unmistakably.

Throughout this period the population had only very slowly increased, communication hardly improved at all, and indeed the dominion of man over nature

little extended. While the auguſt anti-Jacobins of Weſtminſter, with indignant and fearful eyes intent upon the other side of the channel, were denouncing all change as treason, a revolution was developing under their very noses which presently made the objeĉt of their regard seem small, isolated, and conservative. These gentlemen were so intereſted in the attack which the French were making upon the domination of their monarchy and their ariſtocracy, that they had no time to notice that which their own countrymen were making upon the domination of nature herself. How ſtatic the views of the English governing class ſtill were in the seventeen-nineties is teſtified by this very faĉt : that to them the elimination of a Bourbon seemed of greater importance than the partial elimination of time and space. Whereas previously occasional great inventions —such, for example, as printing—profoundly modified for centuries the civilisation of the ages in which they were made, they now, each necessitating a revolution in the habits and outlook of civilised man, follow each other with bewildering frequency.

The induſtrial revolution transfigured the whole world with a suddenness and completeness entirely without precedent : from being well-nigh ſtatic it became dynamic, from being vaſt and myſterious it became small and known. Yet in many essentials its inhabitants have altered little. The reason for this is to be found not in any unalterable quality in the composition of man's nature, but in the rapidity of the

13

changes to which he has been subjected. Before human beings could adjust their habits and their outlook to a civilisation dominated by the railway, the telephone and the wireless came, changing its very basis. At the same time the aeroplane and cinematograph were making modifications equally fundamental. Discoveries which in the old world would have overshadowed nine centuries are to-day no more than nine days' wonders.

At the beginning of the reign of George III the majority of Englishmen were countrymen : labourers, small farmers and squires, who could obtain little that they or their neighbours did not make with their own hands, from materials grown or quarried in their own neighbourhood. To-day the great majority are townsmen, many of whom would be indignant, and righteously indignant, if they could not command, without rising from their beds, commodities from the four corners of the earth to be brought within a few hours to their own houses. The impulse which has wrought this most complete and amazing of revolutions has been directed entirely towards the mobilisation of the world's resources, to the entire neglect of their distribution. This (to our eyes) grotesque neglect is hastening the end of the industrio-capitalistic dispensation. Single movements cannot accomplish everything. History will give to the past and present age the praise or blame for this impressive mobilisation, but to the next belongs the problem of distribution. New things do not always come out of Africa, nor can it be foretold in which quarter of

the heavens a new ſtar will appear ; so it is difficult to foretell whether some solution will come from the Eaſt, where the government is attacking and supplanting large-scale private enterprise, or from the Weſt, where private enterprise, organising itself in ever vaſter units, seems likely to absorb the government. At all events it is abundantly clear that the present syſtem has produced inequalities of wealth so extreme as to be intolerable alike to the sentiment and the reason of the age.

Of the infinite number of circumſtances which combined to bring about the induſtrial revolution, two emerge clearly : the application of scientific discovery to the needs of daily life, and the unprecedented extension of the practice of division of labour. Scientific knowledge of a very high order had exiſted periodically for thousands of years before. But the scientiſt had always been looked upon as a curious man apart from society, whose activities and idiosyncracies, though intereſting in themselves, could have no practical importance. The artiſt, on the other hand, was always regarded as a practical necessity, whose idiosyncracies were nothing but a nuisance, a hindrance to the efficient execution of work which formed an integral part of the setting of society; as the man whose decorations made the homes of heroes fit to live in, or whose propaganda made the heroes themselves out of ordinary princes and soldiers. Magnificent surroundings for the rulers while they lived, impressive memorials of their deeds when they were dead, were considered as essential to the

prestige and security of the ruling power as is a laudatory Press to-day. From the beginning of organised society to the eighteenth century such a view was held unquestioned. Every royal monument, from that of Cheops at Memphis to that of Louis XIV at Versailles, bears testimony to this truth.

Neither were the activities of the artist any less necessary to organised religion. Whether he insured by his skill at portraiture the preservation of the personalities of his sitters in this world and the next as he did in ancient Egypt, or whether he made the scriptures and the doctrines of the Church comprehensible to an almost illiterate population, as he did in mediæval Europe, matters little. The essential fact remains : that the work of the artist was a practical necessity, religiously and politically.

To-day all this has been exactly reversed. The man of science no longer resembles the aloof scholar of Hellenic times, theorising philosophically upon isolated and curious phenomena, nor the strangely-garbed magician of mediæval times, with his crystal on the table, his love potions on the shelves, and his stuffed crocodile suspended aloft. The stuffed crocodile has changed his habitation. The magician has become the scientific man, whom ordinary business men address almost as an equal, as the first servant of the community. The attitude of these good men towards the services of the scientist is analogous to the attitude of the human race towards the bees for their blind collection of honey ;

towards the ovine kind for its meek yielding of its wool and flesh; towards master Reynard for his sporting defence of his brush and pads.

How right and how normal such an attitude is! In a great age of science like the present, the scientist with the true vocation makes his discoveries and advances the frontiers of knowledge not because he wishes to serve humanity but because he cannot help it. It is for the enlightened selfishness of society to take advantage of such a passion and to harness it for the common good. The world is moved so little by consciously formulated ideals and so much by necessities imposed by circumstances, that its highest form of wisdom must always be to accept what is given and to make of it the highest possible use, whether the gift be the divine wisdom of Jesus Christ, the blind industry of the bee, or the curious preoccupation of certain of mankind with beauty and knowledge. As the grasshopper was suspected by Æsop of imagining that a hot summer's day would prolong itself into eternity, as one feasting finds it hard to conceive of hunger, so mankind regards as permanencies the fleeting gifts of Heaven.

The courage and resource of the average engineer of to-day will appear to our descendants no less miraculous than the insight and skill of the average artist of the time of Michelangelo does to ourselves. There will come a time when bridges, tunnels, and aeroplanes designed by scores of men who are in no way remarkable to us, will be revered as monuments of an age of

mechanical miracles, of an age so universally mechanical that every schoolboy underſtood the elements of the abſtruse science of engineering.

Although the induſtrial revolution had run several decades of its course before the ſtuffed crocodile had made itself entirely at home among the paraphernalia of the ſtudio, events had for several centuries been tending to undermine the artiſt's position in the community. Until the renaissance and the reformation there had been an almoſt exclusive subjeƈt for all art, the Catholic religion. Since this subjeƈt was underſtood by everyone, the work of even the moſt abſtruse artiſts had a definite meaning for the simpleſt people. Then came the renaissance, bringing with it either a frankly classical subjeƈt-matter comprehensible only by a learned minority, or a classical treatment of the old themes, which rendered them as things somewhat remote. The reformation succeeded, which favoured an entirely secular subjeƈt-matter.

During the century that followed these two movements kings and princes succeeded the Church as the patrons of the artiſt. A century later the ariſtocrat was tending to supplant both. All the time the artiſt's *rôle*, important as it remained, was becoming less and less intereſting to the people in general. The Church had been something universal, of equal relevance to all the nations in Chriſtendom and to all classes of society. The monarchy embodied the pride and ſtrength of a single nation, and the ariſtocracy nothing more than a con-

ception of life that could only positively affect a single class. As his patrons have become more exclusive it is natural that the work of the artist also should gradually have lost the universal quality it had once possessed.

This gradual narrowing of the artist's functions was at once drastically accentuated and entirely reversed by the industrial revolution. The functions of the best artists in the widest sense of the term were, from the social standpoint, reduced to nil. They became independent of any patrons, and servants only to their own moods, theories, and conceits. The worst became not so much servants as slaves, not so much slaves as prostitutes, to the new industrio-commercial society. Although this last class as a sociological phenomenon is no less important than the other, it is, judged æsthetically, hardly worthy of contempt. The new order of things showed itself from the start inimical to the activities of the good artist. The unprecedented growth of the population, the absence of any class possessing both the wealth and the taste necessary for art-patronage on an important scale, and the complete absence of any control which might have kept the artist as a social factor, ensured his exclusion from the main current of modern civilisation.

It would be well to examine briefly these three principal causes of the modern schism between art and society. Historians are at a loss to account satisfactorily for the sudden terrific increase, from the second half of

the eighteenth century, of a population which had so far as is known grown very gradually since the norman conquest. But certain it is that this sudden expansion was aggravated by the exigencies of mass production and large-scale farming. Before these developments the small farmers, not rich but hopeful and cautious, waited to marry until they could well afford it. The farmer who employed labour preferred young unmarried people who slept in his farmhouse and ate with him at his table. The new system changed all this. The enclosures deprived the small farmers of their land. The sudden change brought about terrible distress, as sudden economic changes will. The dispossessed either drifted to thoes sordid barracks for cheap labour which were springing up around all manufacturing towns, or into the hovels provided by the big farmers. Robbed of hope, and consequently of prudence, these wretched people multiplied recklessly.

Matters were suddenly made worse in 1795 by the well-intentioned but misguided measure commonly known as the Speenhamland Act, which secured for each family a weekly allowance of eighteen pence for every child that was born. Small wonder that the population increased if a mother of a family of illegitimate children earned a better living than a man who worked for six days in the week at the miserable current wage! Soon afterwards the effect of the advance in medical science began to make itself felt by a rapid decrease in the death-rate. Dreadful as were the im-

mediate effects of so chaotic a multiplication, without it British industry would never have enjoyed its century of predominance nor the Dominions beyond the seas been peopled by the British race.

The first effect of mechanical civilisation upon the individual was to make of him a machine server instead of a craftsman. In a generation or so he had, generally speaking, already lost his former manual initiative and skill, and become capable of doing little besides controlling a machine which was in most cases nearly foolproof. How simple such labour was became evident to all the world when during the last war the so-called " skilled " workmen of all ages were replaced during their service with the army without much difficulty, largely by inexperienced little girls. Small wonder, when the workmen of the nation became, as workmen, so effete that they were helpless before they knew where they were, in front of the only economic organisation which could produce the gigantic volume of commodities that they needed, by making use of their debased and mechanical labour. A vicious circle came swiftly into being : machinery arrived, and increased the population ; the population, ever vaster and ever more helpless, became more and more abjectly dependent upon the machinery largely accountable for its size and entirely for its manual incompetence.

There is no reason why a social organism consisting largely of an immense manually incompetent population, subservient to machinery, should by its nature be

inimical to the activities of the artist. But when such an organism is so vast and is guided by such principles as were dominant in the England of the early industrial revolution, a conflict cannot be avoided. In a well-organised industrial state there should be no reason why beautiful things should not be manufactured in vast quantities. Such things could be designed, which would make a virtue out of the necessity for their being machine-made. Without some form of economic collectivism such a consummation is impossible. For the first result of the introduction of machinery into an individualist state being necessarily the destruction of the public taste, a public demand for shoddy goods will be created, a demand which the individualist producer—a man often without overmuch public conscience—will set himself with ardour to satisfy.

The assertion that the degradation of the public taste must inevitably follow the introduction of machinery into an individualistic society needs a little amplification. The average pre-industrial man was no more convinced æsthetically than the average pious peasant is convinced religiously. The one, living in a community where everything was made by hand according to slowly developing traditions of extraordinary beauty, was as unlikely to make something ugly as the other, living in a community where sincere but simple religious faith is the rule, is to become a heretic. The power of instinctive faith and the power of creating beautiful things, where they are widespread, are de-

pendent rather upon habit and environment than upon
personal conviction. And habit and environment are
precisely the factors which are changed when machinery
is introduced among a people accustomed to making
what they need with their hands, or when the pious
peasant migrates to an atheistic community. Bereft
of their former environment, their way of life forcibly
changed, the craftsman and the pious peasant, possessing
little in the way of internal personal convictions to fall
back upon, lose almost instantly their intuitive good
taste and skill and their faith respectively.

The people of England proved no exception to this
rule. Machinery destroyed within the space of a few
years the instinctive good taste which comes naturally
to those accustomed from childhood to seeing nothing
that is not well designed. Hence the immense and ever-
increasing demand for goods which are, æsthetically
speaking, of the vilest type, which came into existence
with machinery.

There was only one way in which such a catastrophe
could have been avoided : by an early marriage between
good design and mass production. Had an efficient
and enlightened government insisted upon such a match
the industrial age might have avoided the distinction of
being the first-known civilisation to be unashamedly ugly.
But in the England of the late eighteenth century such
a consummation was impossible. Individualism was at
its zenith. The greatest political thinkers of the time
denounced government action on theoretical grounds,

business men regarded it first with contempt and later with hostility.

At the beginning of the eighteenth century the divine right of the Church had given place to the principle of toleration, the divine right of kings to the compact and natural liberty, and an absolute and divinely revealed code of conduct was being undermined by utility. Church, monarchy, and absolute code of morals were dethroned by the assertion of the rights of the Individual. This doctrine of individualism found its most powerful expression in the hands of Locke and Hume. The new ethics which Maynard Keynes once aptly defined as being no more than a scientific study of the consequences of rational self-love, placed the individual at the centre. The matter was no less lucidly stated by Hume when he said : " The sole trouble virtue demands is that of just calculation and a steady preference for the greater happiness."

Such a view was felt to be disruptive, and Society once more put forth her claims against the individual, using for argument the new feeling for equality which had been creeping into political philosophy. Rousseau made Locke's social contract into the general will, and Bentham gave to utilitarian hedonism a wider social significance. Despite this reaction individualism remained as vital. Presently the gulf between the individualistic and the socialistic school was bridged by the Economists. Archdeacon Paley had already declared that Virtue was doing good to mankind, for the sake of

everlasting happiness. But it was the economists who made acceptable this conception of a divine harmony between individual advantage and public good to practical men by giving the notion a scientific basis. Needless to say with what enthusiasm business men hailed the doctrine that individuals pursuing their own ends in an enlightened fashion in conditions of freedom were automatically promoting the general interests of humanity. The philosophers had declared that governments had no right to interfere, the economists had shown that governments had no need to interfere. The ineptitude of such administrative regulation as there had been during the century lent support to a general hostility towards direct state intervention in economic affairs which lingers still. Further, the immense material expansion of the late eighteenth and early nineteenth centuries was essentially the result of individual initiative.

By a peculiar and tragic irony, at the very moment when the conditions which had made *laissez-faire* justifiable were about to undergo a fundamental change, its most persuasive advocate appeared. It is not without significance that Adam Smith had completed his *Wealth of Nations*, which was published in 1776, in the previous decade. This work was based on a study of conditions which prevailed without much change for the two centuries which preceded the industrial revolution. So powerful was its effect that it was taken as a guide to the industrial age, when in reality it was only relevant

to the state of society which existed before it. The misfortune was that the younger economists who fell under his influence viewed the changing complexity of the new era with a vision only adapted to the old.

To this most tragic of coincidences, the almost simultaneous arrival upon the scene of forces infinitely more powerful for construction or destruction, for good or for evil than any dreamed of by the ancient world, and a philosophy of unrestricted individualism, is attributable something radically unsound in the economic organisation of England. Of this unsoundness the segregation of the artist is only a symptom. The industrial life of other countries was developed when *laissez-faire* had begun to yield to a more collectivist outlook. But in our own it was otherwise. In walking among the factories in an English industrial centre one sees evidence on all sides of great character, resource, and initiative. Yet all the time it is impossible to avoid a sense that what is before one is nothing more than a series of individual efforts, and being oppressed by the palpable absence of more than the most rudimentary co-ordination. Visions appear before one of the past conflicts between individualism and co-operation, visions of haughty steel-clad knights of ancient France being hurled ignominiously into the mud because a few score English peasant lads could discharge their arrows " so wholly together " ; or of those superb Frenchmen of a later age, who charged in isolated columns which withered uselessly beneath the converging fire of opponents whose

alignment permitted closer co-operation. The mediæval knight could without difficulty have cut to pieces a dozen of his leather-jerkined enemies had they fought as independently as he; the Frenchmen of the napoleonic epoch could hardly have been inferior, man to man, to those ancestors of ours whom the Great Duke apostrophised so harshly as "the scum of the earth." Yet the defeat of both by more highly organised opponents was decisive.

English manufacturers and merchants established their priority by taking decisive advantage, as individuals, of a concatenation of circumstances that is unlikely ever to occur again. But they possessed other qualities besides the wit to take full advantage of the disorganisation of their rivals' economic system by recurring continental wars and of their own countrymen's epochmaking inventions. Courage and initiative enabled them to retain their priority for a century, relative generosity of conduct prevented the envy of their neighbours from assuming proportions too threatening, and honesty brought them the trust of the entire business world. Their foreign rivals, often as inferior man to man as was the English archer to his steel-clad adversary, took, as he did, the only possible road to victory. Without England's prestige and many of the qualities which went to build it up, without many of the material advantages of England, such as the proximity of her iron to her coal, her geographical position, her climate, her at least partially effective lordship of a quarter of the

globe, their superior organisation enables them year by year to better their position in comparison with hers.

But the tragic coincidence resulted in an evil far less tolerable than an imperfectly co-ordinated system of production. The chaos, the squalor and the absence of proportion in the life of the average man of our time is directly attributable to it. Before the birth of eighteenth century rationalism all guardians of morals were agreed, *mirabile dictu*, upon one point. All alike, from Popes to puritans, regarded man's instincts, with anxious eyes, as passions which should be carefully controlled when they could not be utterly resisted. The new philosophers, however, taught that these instincts, far from being dangerous passions, were not only the surest guides to man's private conduct but also the best possible means of attaining the general welfare of society. To the impassioned socialist of a later day such a belief appeared merely a conscious attempt to create a god by enthroning man's natural selfishness, in order to justify the farce of " free " bargaining between powerful master and helpless man, and the many atrocious acts in defence of private property.

A sympathetic glance at the England of the eighteenth century will show how naturally the sincerest minds were drawn towards this attitude. It does not need great imagination to visualise the attraction and the plausibility of this new revelation, which unified and elevated to the status of a religion the two greatest positive passions of the age—personal liberty and material

progress. How directly relevant to life, how firmly rooted in ascertainable truth, and how hopeful it must have appeared, in comparison with the ancient shibboleths of the churches, oppressive, unsupported by evidences more tangible than those of Archdeacon Paley (himself a convert to the new faith), and, for the majority of sinning mankind, hopeless. Nor is the impatience of the opinion of the age with the older system hard to understand when we remember that it had long since ceased to represent a living philosophy of rational order, and had degenerated into a stronghold of irrational and intolerable privilege. Feudalism no longer sought to justify itself by the idea of function, but by that of divine right. Easy-going and tolerant as were its prophets while it was in the process of definition, once defined, the new faith claimed as exclusive an obedience as monasticism itself, with this difference—that while monasticism demanded only the voluntary obedience of a small class, the devotees of the new cult of production sought to impose its discipline upon the entire population. If in this new world no more was required of the best of men than that he should make as much money as he could, what scope was there for those other activities necessary not only for a civilised life but for a tolerable existence ?

Of these activities two were straightway banished from the community : the pursuit of pleasure and the pursuit of beauty. So intense was the preoccupation of the early industrial age with production, that the first

was considered wrong and the second irrelevant. Nothing, it was thought, muſt be allowed to retard in the smalleſt degree the free operation of man's enlightened selfishness, by which means alone could sufficient commodities be produced to reduce to a minimum the demand that the satisfaction of his elementary material needs made upon his energy. In this relative independence of material necessity the age for-saw the trueſt freedom, the condition essential to the blossoming of the arts and sciences and all the beſt of man's activities. Mass production seemed to the optimiſts to be about to take the place of the slave labour which formed the basis of the civilisation of the ancient world. What could have appeared more ideal than that the leisure necessary for the higheſt forms of civilisation should be created by machinery worked by free citizens inſtead of serfs? The millennium appeared to be almoſt immediately obtainable, without violation of the dictates of liberty.

Nor has this view been since seriously modified. Our own optimiſts inform us that if our induſtry could be more highly organised, the satisfaction of the material needs of man would not require more than two hours' work daily on the part of the producers. Then they proceed to conjure up idyllic visions of a world in which the inhabitants may spend twenty-two hours out of the twenty-four (less, of course, the time necessary for sleeping and eating) upon the cultivation of the arts and sciences. The fallacy of such a line of argument

# The Industrial World

must be apparent to anyone who has ever seriously attempted to conceive of his own or anyone else's material wants being completely satisfied permanently.

Human organisations, usually called civilisations, possess and have always possessed one quality in common : that of evolving conſtantly towards greater and greater complexity. They break down when the ſtrain imposed by their complexity becomes greater than they can support. After these collapses, societies begin by organising themselves with greater simplicity, but presently the process begins anew. This consideration alone is sufficient to dissipate the mirage of the two-hour day. However perfeĉt a syſtem of produĉtion might be, its chances of keeping pace with the demands of a society whose complexity increases with the rapidity of our own may be discounted as insignificant.

In human affairs, means have ever loomed larger than the ends which they purport to further. Do torturers in the name of religion remember, in their ecſtasies of cruelty, the welfare of the souls they are engaged in saving ? Are conquerers of races they deem inferior, in their pride of dominion, mindful of the culture which they are oſtensibly imposing ? And so in the induſtrial revolution the ends, the great things which were to come from the use of the mighty new servant machinery, were forgotten, and the means, produĉtion, was set upon the throne. To say indeed that they were forgotten would be to underſtate the truth. Certainly they were remembered sometimes, but then only to be prescribed.

# The Artist

The results of this passionate preoccupation are evident in any English industrial town. In the early days of the metamorphosis the gigantic expansion and intense concentration of population and industry rendered it obvious that the whole face of the country was about to change, that immense cities were coming into being by the score. Yet so complete was the general subservience to the spirit of gain that to it alone was given the planning of this new world. Even profit did not look beyond its own nose. And so cities arose on every hand beside whose wealth the riches of the great commercial cities of the past was insignificant. Yet, could they have walked the streets of Manchester, inhabitants of old Tyre or Venice, Amsterdam or Genoa, would not have believed that to be possible. That the possessor of such unbounded wealth, abundant and cheap labour, with a sufficiency of fine architects at its disposal, should have been so mean, so dirty, so utterly squalid and chaotic, would have passed the comprehension of these ancients. Accustomed to consider town planning the first necessity of a civilised society and beauty the primary mark of greatness, bred in cities made lovely by the symmetry of streets and the grandeur of public buildings, churches and temples, they would have marvelled to hear that others of vastly greater resources were not only without these amenities, but without drainage or public water supply.

At the very moment when the dreariness of his mechanical labour and the indescribable nature of the

workman's surroundings demanded that he should be compensated in other directions, the two best means of effecting this were opposed most strenuously by the employing class. Education was frowned upon, as it was thought that the workman, once educated, would become discontented with his lot and attempt to change it, to the detriment of the cheap and teeming labour market. Nothing served to rouse the resentment of the employed against the employing class so effectively as the twofold onslaught made upon popular amusement. In former civilisations the state had provided public entertainment, though often of the most brutal description, and public parks. Long hours, which had always existed, were mitigated by numerous saints' days and holidays. But to the employers of the early industrial revolution, amusement appeared to be a mere interruption of the all-important aim—production, which they conceived to demand a barren life of long and empty hours. In accordance with this view some magistrates used to refuse to license public-houses where concerts were held.

The present day witnesses a complete *volte-face*, and the workman is encouraged to use the public-house for any purpose rather than that for which it is built.

The most advanced public opinion of the time intervened in this question to increase the immediate loss of the workman.

For not the least singular feature of the period with which we are dealing was the degree of unanimity which

existed between the intellectual and the man of affairs. Generally speaking, intelligent opinion approved the actions of the commercio-industrial community and exercised an appreciable influence upon them. In this case such opinion not only agreed with the employers' attitude towards all amusement, but violently condemned upon humanitarian grounds a number of the working man's pleasures. Several of these were indeed of the most barbarous description, but that did not make their prescription a lesser source of bitterness.

Admirable as were the reformer's aims, the moment which they chose to achieve them was unfortunate for the relations of class with class. Sufficient causes of mutual fear and hatred there already were—in the French Revolution, the enclosures, the increasing misery of life and increasing disproportion in the distribution of wealth. No wonder that the attitude of the possessing class towards pleasure was regarded by the poor as an attack of unjustified savagery upon their last remaining earthly joys.

To return to the bearing of these things upon the position of the artist. There was no reason why he should not have maintained a living contact with at any rate some part of the community, had there existed a class capable of standing as patron to him. The ever-narrowing sphere of the artist from the time of the renaissance and the reformation onwards has already been mentioned. Although the service of an exclusive class is likely to be a more limited activity than the

service of a church which embraces the whole of Christendom, it must not be forgotten that the class of which we are speaking was the possessor of singular qualities. To it George Trevelyan, an historian with a sense of values unsurpassed in our time, pays a fine tribute. " It had faults," he says, " of which drunkenness and gambling were the worst, but it lived a life more completely and finely human than any perhaps that has been lived by a whole class since the days of the freemen of Athens."[1]

The same author rightly observes that this aristocracy was at that time the art patron of the world. It became the rule for all who could afford to do so to spend the few years that intervened between the completion of their education and their *débuts* in Parliament, in making the grand tour. During this time they lived in the most polished society of the capitals of Europe, and acquired collections of the then fashionable old masters, sculpture, and *éditions de luxe*. They subscribed not only to magnificently bound and printed editions of the classics, but also to those even more sumptuous volumes commemorative of the births, the marriages, and other doings of continental princes, the pomp of whose bindings excite the wonder of the bibliophile.

To digress for a moment upon these tomes, it was once observed of them that the less important the prince upon whose account they were issued, the more over-

---

[1] *British History in the Nineteenth Century,* by G. M. Trevelyan.

whelming the magnificence of the commemorative volume. It has been further noted in pursuance of this theory, that the only English prince and princess to be so honoured lived and died without material kingdom. For after their deaths the Old Pretender and his wife were accorded such memorials by the generosity of the Vatican.

Thus during the many months in the year which these lords of fashion spent at their country houses, the latest literary and artistic opinions were disseminated among the smaller squirearchy. Fashionable society had, by the close of the century, come to regard art and literature as no less important than politics, athletics, and dissipation. Consequently, through the operation of the not altogether unwholesome snobbery of the age, the great English writers were popularly counted among the foremost of their race.

The industrial revolution struck a death-blow at this graceful society, which lingered on in its ordered and beautiful environment to make more poignant by contrast the wretchedness and confusion of the new world which was being born. Almost ideal as the life of this aristocracy must seem to anyone disillusioned by the ugliness of the age which succeeded, it must not be forgotten that had it been conducive to a clearer intellectual outlook and a less selfish social mood, the new forces might have been given something of order and symmetry.

But the spirit of the new age lured all men, from the

aristocrat to the labourer, into the battle for profits. They entered it not because they had grown a whit more selfish but because they could not help it. Changed circumstances, brought about by the great inventions, combined with the natural selfishness and lack of vision inherent in the average man, precipitated a situation which forced the hands of all. The revolution threw up an order of men with whose industry, hardness, thrift, and knowledge of the new conditions, the landowning class could not—save in exceptional cases—compete. These men, the new rulers of England, to whom the *laissez-faire* doctrines supporting unhampered and exclusive struggle for profits were the most immediate realities, regarded artists of every kind, architects (as opposed to mere builders), and even economists as irrelevant. What need indeed for these last when the ultimate truths of economics were already known ? What need for a little fussy man-made order when each little selfish unit was being attuned by its very selfishness to a divine harmony ? Or for beauty conceived of man, which could but serve to obstruct the completion of that higher design which was being evolved by the individual struggle for profit ? Or for pleasure, which weakens the adjective in the all-important shibboleth " enlightened selfishness ", and strikes thereby at the very heart of the new revelation ? O son of man ! If one knew not how little your ideals have affected you in practice it would seem that your faith were not little but too great.

Human nature and social usage combined to relax

# The Artist

considerably in practice the asceticism of the new faith. A certain amount of pleasure, even a little actual dissipation, might be allowed—to those who could afford it. Also it seemed that a certain amount of beauty (at so many pounds the square foot) was necessary for the walls of houses of people of position. The new magnates were too intent upon their struggle for profits to have the leisure to argue about such matters. If a little painted canvas and chipped marble pleased their wives, and made their residences resemble those of the more anciently established (whose social power was still enormous), by all means let them have these baubles. So the makers of the baubles were patronised by people of no artistic education immediately after the degradation of the general taste by the introduction of machinery.

The better artist had been prevented by the principles of *laissez-faire* from making his contribution towards the new England, and thus from becoming an integral part of its social system. His patrons were losing their wealth and forgetting their taste : he was being thrown upon his own resources and forced more and more to become his own master, or more accurately, the servant of his every whim, the recorder of his every personal fancy. Far different was the lot of his prettier, more timid brother. His anecdotal, pseudo-classic productions found great favour with the new plutocracy. They were bought in enormous quantities, and the epoch for the painter of shoddy and vulgar pictures was something of a saturnalia.

## The Industrial World

But while he yet feasted the avenger was at hand. Most of the criticisms uttered in the glowing biblical prose of John Ruskin strike the modern critic as being but little removed from the realm of the grotesque. His passionate judgments were so evidently the result of his sympathies that they repel more finely balanced minds, while to the majority their now unfashionable tendency is sufficient ground for condemnation. Ruskin's fundamental weakness lay in his failure to perceive that art has a moralty of its own, subject entirely to its own laws ; and he expended his almost unsurpassed eloquence in a fruitless attempt to impose upon it human morality. To him must be given the lion's share of the blame for the Gothic revival. For sheer degradation of style, the vast numbers of buildings which owe their inspiration to it have never been approached.

Enslaved as his powerful intellect was by his instinctive loves and hatreds, he felt and wrote about the arts with a passion the like of which England had never yet seen. To him they were never an affair of styles and techniques, mannerisms and patterns, but always something deeply rooted in the life of humanity, representative of the fundamental causes, tendencies, and beliefs which move it. A man of power and sincerity, holding the opinions which Ruskin held, could hardly be expected in his capacity of critic of the arts to act as advertiser and mentor to those who were so busily engaged in pandering to a taste which was growing daily more corrupt. He acclaimed Turner, encouraged the Pre-Raphaelites, and

patronised Prout.  Historically, the reputations which he helped to blast are more important than those he helped to make.  The chances are that Turner and the Pre-Raphaelites, appealing as they did to finer tastes, would have been recognised, but the imposture upon the ignorant might not have been exposed for generations, for the simple reason that sincere admirers of real works of art become such by intuition, while collectors of rubbish have generally to be instructed.  The result of Ruskin's activities was not that fewer bad pictures were painted but that those that were, were taken a trifle less seriously.  For, nervously disenchanted, the great army of English collectors had transferred their patronage from the treacherous marshes of contemporary production to the securer heights of antiquity.  Since that time even the most popular artist has been a little suspect.

Half way through the nineteenth century the tide changed, the industrial revolution dwindled into an industrial dispensation, and *laissez-faire* receded into the distance.  This sudden recession of the impressive tide of individualism was occasioned, in the spheres of politics and industry, by a general sense of alarm at the increasingly chaotic nature of the conditions which prevailed throughout the country.  The disorder had become menacing.  But instead of striking at the root of the evil and rebuilding the slums as a more vigorous and clear-sighted society would have done, it merely devoted its attention to making life in them just tolerable, thereby encouraging their growth, disarming

criticism, and poſtponing fundamental reform until a time when the problem shall have grown too vaſt and too intricate for solution at all. For a society to allow such conditions to arise is to invite cataclysmic revolution or irreparable decay. Under such circumſtances the two go hand in hand; for revolution is the mirage at which dying societies are wont to clutch.

In the religious and philosophic spheres, individualism received a check from a new series of revelations. The moſt important of these, Charles Darwin's *Origin of Species*, appeared nine years after the turn of the century. Man was, it appeared, no longer the servant or the enemy of God. Far from having been created in His image, he was but the laſt of a·chain of monkeys. His claims to a unique origin and exclusive sovereignty were denounced as baseless superſtitions. But there were other and conflicting inferences popularly drawn from these revelations. Now that a personal God had been abolished it seemed that the principles of *laissez-faire* were applicable not only to man but to the universe itself. Its catchwords, "The survival of the fitteſt" and "The ſtruggle for exiſtence" juſtified in the popular mind the exiſting induſtrial syſtem. The effect of darwinian thought was to give a scientific sanction to induſtrialism while it robbed the individual of much of his faith in himself. It was merely a ſtep towards the enslavement of man by the system which he had created.

Government interference is to this day generally

41

disliked among us, but it is nevertheless not only submitted to but considered inevitable. The instrument of British governmental interference, the civil service, is the most efficient in the world. Tory majorities pass socialistic measures, and away to the East a government holds power which has socialised Russia's entire industrial means of production to the extent of 89 per cent.[1] Beyond the Alps another government is frankly endeavouring to organise a whole country as a single unit of production. The reversal of *laissez-faire* is on the point of completion. It might reasonably be supposed that this *volte-face* would have restored to the artist his ancient place in the community. But such has not, so far, been the case. Helpless without the machinery of mass-production at his disposal, before a population grown vast overnight, dismissed because a state governed by *laissez-faire* had no use for him, rendered patronless by the corruption of the public taste—the artist became, if successful, a parasite, if not, a pariah. A parasite or a pariah, that is, from the point of view of society. Bereft of civic relationships, the original artist has been enabled during a century to achieve a body of work more profoundly personal and individual in its vision and execution than any in history. Despite its many technical weaknesses, work of this century, by the intensity and boldness of self-expression, is likely to hold an unique position in the eyes of future ages. An individualist society had forced individualism upon a

---

[1] *Towards Socialism or Capitalism ?* by L. Trotsky.

class whose functions had before been almost entirely
social.

Occupied with expressing themselves or filling their
pockets, the artists now looked with unseeing eyes upon
the outer world. One of them founded a craft move-
ment which continued while he lived, always swimming
palpably against the tide of history; others lectured to
audiences as appreciative as they were inactive upon the
relations of art and the state; others occasionally raised
their voices in protest when barbarian hands were about
to lay low some ancient object of beauty. Of the artists
of the nineteenth century in England, the remotest
from civic life, the most insistent upon their own
individuality, were those who took their name from its
ultimate decade.

The artist is becoming day by day more urgently
needed by the community. The community is not
itself aware of its need. But the effect of the increasing
sordidness is evident upon the character of the people,
whom it forces to indulge more and more in the joyless
and mechanical excitements provided by the great
trusts.

While the contrary appears upon the surface to be
the truth, in reality the need of the people for the
artist is greater than his need for them, for he, made to
turn in upon himself, has discovered resources which go
far to compensate him for his former position.

The great English inventors harnessed science, which
had before been a mere plaything for scholars, to the

43

needs of the daily life of the people. It remains for their descendants to bring art, not as Oscar Wilde did, from the studio and the museum to Mayfair, but into the highways and byways, into the factory and the home of the ordinary man. The relations of mass-production and art is one of those problems which our descendants take their ancestors most sternly to task for failing to attack. But at present the problem of distribution looms so large and menacing that all others perforce must wait upon its solution.

## Chapter Two

### *Qui nous delivera des Grecs et des Romains?*

OPERATING conftantly throughout the whole hiftory of art, it is possible to recognise two diftinct forces which it is ftill convenient to differentiate by the old terms of classic and romantic. The differences between these two forces, when closely examined, tend to disappear, and classic and romantic are seen to be so closely inter-woven that it becomes impossible to tell with any degree of precision where the one begins and the other ends. For inftance Goethe, the ardent hellenift, waxed enthusiaftic over the cold derivative classicism of Palladio, but confronted by real classical antiquity he was forced to admit that he experienced " a ftrange, half-unpleasant sensation." Byron, who epitomised in himself an entire age of romanticism, founded his poetry with an almoft slavish assiduity upon that of Pope, the moft accomplished classic poet England has produced. In the one case a great hellenift is unable to recognise the greatness in what he imagines that he loves so much. In the other a great romantic can find no more suitable vessel for his burning inspiration than the medium of the moft characteriftic of the

45

classics. Although the two themes are found to be entwined with a baffling complexity even in those cases where at first glance they appear to be most clearly separated, they can nevertheless be clearly conceived of as two forces not only distinct, but actually antithetic.

These two attitudes have already been contrasted with such authority and comprehensiveness that the temptation to reproduce the comparison in full is not to be resisted. It occurs in D. S. McColl's scholarly and undeservedly neglected *Nineteenth Century Art*. In place of the terms classic and romantic he has used olympian and titanic.

Olympian art (he writes) demands beauty not only of the whole pattern and effect of a work, but of the figures and objects themselves that make it up : a beautiful picture is not enough, it must be a picture of beautiful persons and things. Of creatures and things, it holds, one perfect form exists, and can be discovered ; or more exactly that for each, a cup or a human being, there is a small number of types capable of infinite fine variation within narrow limits. Personal taste, ' the expressing of oneself ', is therefore a deviation, unless it means a little bit of nearer approximation to the perfect type. This measure applies to ' form ' in the sense of behaviour as well as to other appearances. The art, therefore, does not admit of indulgences in sensation or emotion as pleasant, exciting or curious : they must be such as the state can approve. To exhibit this wholesome matter with clarity, serenity, and temperance, it excludes such colour, shadow and vapour as would render form less complete or distract the eye from its perfection. Violent action and passion are also excluded, because this art aims at affecting the mind not by an extremity

of emotion but by the more bracing rhythms of beauty and the proud balance of ſtrength controlled. It is therefore not a dramatic art ; aċtion is admitted only as it might be into a dance or pantomime, by so much allusion as the rhythm permits, or as speech is sublimated in music. Character, too, is limited ; there is a certain variation of types within beauty, leaning to more of ſtrength, graciousness, dignity ; and age is admitted on terms. But there is a conſtant setting towards a canon of proportions, and when the poetic life of the art ebbs, and fine and intense variation within its narrow limits dies out, dead formula at once emerges, decent in things of use, if use has not burſt the pattern, but intolerable in imagery.

And of the drawing of the titans :

Its aim is to add to the ſtill-life element in form an equivalent of movement, energy, feeling, extreme character, vehement and rebellious passion. To give emphasis of relief, muscular ſtrain and torsion it uses a vigorous contour ('I should trace my contour in iron if I could,' said Géricault), and models with ſtrong shadow. This drawing, therefore, is not what is called ' correct ' drawing ; it always has an element of caricature ; it exaggerates for the sake of vivacity, and is ready to sacrifice the ſtill-life form to the effect of movement, or the expression of feeling, elongating, amplifying, distorting. Its ideal is that the artist should thoroughly possess the essential forms of the objeċt he draws, so that he may use them freely as inſtruments of emotion, passion, ridicule. The maſter of this school cultivates accordingly the power of drawing without the model, or if from the model, then freely with an intensifying of shape and pose. This art is on the one side dramatic, endeavouring to render the movements and feelings of its subjeċts ; but it is also lyrical and personal, lending to or imposing upon a subjeċt the feeling of the artiſt. . . . The

47

classic ideal is that of a writing which should be the same for all ; the other ideal that of a writing which conveys the fact, but with it the mood and gesture of the writer. The classic teaching the one best common step to all, can drill an army or organise a dance ; the other ideal asks in each man's step, his gait, his style, for the movement that fits and expresses the peculiar character of his machine and temper.

Considered abstractly these two opposite forces are discernible in all art. But in Europe the classic spirit has, as its name implies, taken as the chosen vehicle of its expression that tradition which has its ideals more or less fixed by canons derived from Greek, Roman, and renaissance art.

At the end of the eighteenth century we see this tradition sprawling like an enormous moribund octopus, holding nevertheless the academies, schools, artistic honours, and places of Europe in its grip. A moribund monster, that is, as to inspiration. But as an organisation, a conservative bulwark against change, it had never been stronger. Europe was beginning to become restive under this most plausible and therefore most powerful of cultural despotisms.

For the classic spirit has always exhibited a tendency to impose universally that standard of perfection of subject and handwriting to which it is itself for ever aspiring. It has therefore an aptitude for tyranny with which its rival, with its insistence upon individual character, can never compete. The classic spirit is, in fact, as naturally suited for government as is the romantic

for insurrection. Towards the end of the eighteenth century the rigidity and narrowness of the classic tradition had not only become intolerable to more sprightly minds, but year by year the tradition itself was becoming less and less capable of expressing the more important aspirations of the age.

The slow revulsion of the later eighteenth century from classicism appears at first glance to be significant of nothing beyond the *ennui* of a restless and fashion-ridden age with forms which were grown obviously cold; and the unsuitability of a tradition which, whatever its origins, had become so universal in its pretentions, to a society intensely individualist. In reality this revulsion was significant of something more important and less accidental. The modern mind was emerging and already began faintly to display symptoms of that insatiable preoccupation with the infinite, the relative and the subjective which were finally to become its characteristic realms of speculation. The growth of this new mentality has been marked by an increasing antipathy for the classic spirit.

Oswald Spengler, who has in his *Decline of the West* followed out in great detail this cleavage between what he calls the appollonian or classical and the faustian or modern spirits, observes that for the concept of infinite space which the modern soul has always striven to realise, neither the Greek nor the Latin languages possess a word by which the idea can be exactly outlined. The nearest equivalents, τὸ κενόν and *vacuum*, mean un-

E        49

equivocally a hollow body, the stress being emphatically laid upon the envelope. The idea not being there, there is no necessity for a word to express it. Spengler is keenly aware that each of the great cultures has arrived at a secret language only fully comprehensible by him whose soul belongs to that culture. Despite these doubts he illuminates for us the fundamental classic soul and the central classic problem in a description which for a combination of insight and detachment has not been bettered.

What then was it (he asks) that classical man, whose insight into his own world around was certainly not less piercing than ours, regarded as the prime problem of all being? It was the problem of ἀρχή the *material origin and foundation* of all sensuously perceptible things. If we grasp this we shall get close to the significance of the fact—not the fact of space but the fact that made it a necessity of destiny for the space-problem to become the problem of the Western, and only the Western, soul. This very spatiality (Raumlichkeit) that is the truest and sublimest element in the aspect of our universe, that absorbs into itself and begets out of itself the substantiality of all things, classical humanity (which knows no word for, and therefore has no idea of, space) with one accord cuts out as the nonent, τὸ μὴ ὄν that which *is not*. The pathos of this denial can scarcely be exaggerated. The whole passion of the classical soul is in this act of excluding by symbolic negation that which it *would* not feel as actual, that in which its own existence could not be expressed. A world of other colour suddenly confronts us here. The classical statue in its splendid bodiliness—all structure and expressive surfaces and no incorporeal *arrière-pensée* whatsoever—contains without remainder all that

Actuality is for the classical eye. The material, the optically definite, the comprehensible, the immediately present—this list exhausts the characteristics of this kind of extension. The classical universe, the *cosmos* or well-ordered aggregate of all near and completely viewable things, is concluded by the corporeal vault of heaven. More there is not. The need that is in us to think of ' space ' as being behind as well as before this shell was wholly absent from the classical world-feeling. The Stoics went so far as to treat even properties and relations of things as ' bodies '. For Chrysippus, the Divine Pneuma is a ' body ', for Democritis seeing consists in our being penetrated by material particles of the things seen. The State is a body which is made up of all the bodies of its citizens, the Law knows only corporeal persons and material things. And the feeling finds its last and noblest expression in the stone body of the classic temple. The windowless interior is carefully concealed by the array of columns ; but outside there is not one truly straight line to be found. Every flight of steps has a slight curve outward, every step relatively to the next. The pediment, the roof-ridge, the sides are all curves. Every column has a slight swell and none stand truly vertical or truly equidistant from one another. But swell and inclination and distance vary from the corners to the centres of the sides in a carefully toned-off ratio, and so the whole corpus is given a something that swings mysterious about a centre. The curvatures are so fine that to a certain extent they are invisible to the eye and only to be ' sensed '. But it is just by these means that direction in depth is eliminated. While the Gothic style *soars* the Ionic *swings*. The interior of the Cathedral pulls up with primeval force, but the temple it laid down in majestic ease. All this is equally true as relating to the Faustian and Apollonian Deity, and likewise of the fundamental ideas of the respective physics. To the principles of position, material, and form we have opposed those of straining movement, force

51

and mass, and we have defined the last-named as a constant
ratio between force and acceleration, nay, finally volatised in
the purely spatial elements of *capacity* and *intensity*. It was an
obligatory consequence of this way of conceiving actuality
that the instrumental music of the great eighteenth century
masters should emerge as master art—for it is the only one of
the arts whose form-world is inwardly related to the vision of pure
space. In it, as opposed to the statues of classical temple and
forum we have the bodiless realms of tone, tone-intervals, tone-
seas. The orchestra swells, breaks and ebbs, it depicts distances,
lights, shadows, storms, driving clouds, lightning flashes,
colours etherealised and transcendent—think of the instru-
mentation of Gluck and Beethoven. ' Contemporary ', in our
sense, with the Canon of Polycletus, the treatise in which the
great sculptor laid down the strict rules of human body-build
which remained authoritative till beyond Lysippus, we find
the strict canon (completed by Stamitz about 1740) of the
sonata—movement of four elements which begins to relax in
late-Beethoven quartets and symphonies, and finally, in the
lonely, utterly infinitesimal tone-world of the ' Tristan ' music,
frees itself from all earthly comprehensibleness. This prime
feeling of a loosing, Erlösung, solution, of the soul in the
infinite, of a liberation of all material heaviness which the
highest moments of our music always awaken, sets free also the
energy of depth that is in the Faustian soul : whereas the effect
of the classical art-work is to bind and to bound, and the body
feeling secures, brings back the eye from distances to a Near
and Still that is saturated with beauty.

The underlying cause of the revolt against classicism
was the profound antipathy which existed between the
classical and the incipient modern spirits. From the
protagonists of this revolt its meaning, nay, its very

enemy, lay darkly hidden. They failed to recognise in this antipathy the *casus belli*, juſt as those writers and artiſts who reaćted againſt induſtrialism failed to recognise the objećt of their reaćtion. Indeed, they fought more blindly, for among the others we find Robert Southey, acutely aware of the squalid chaos towards which the country was ſteering, saying : "The Augean ſtable might have been kept clean by ordinary labour, if from the firſt the filth had been removed every day : when it had been accumulated for years it became a task for Hercules to cleanse it "[1]—and even William Blake, for all his unearthly visions, discerns in " the dark Satanic mills " the earthly enemy.

But so far as I am aware, no writer of the eighteenth century voiced his sense of the deep incompatibility between classical spirit and tradition, and the free development of contemporary culture. The underlying necessity for the emancipation of the Weſtern mind from the toils of this tradition being ſtrongly sensed but quite unperceived, it was natural that the firſt attack should fall upon the forms of classicism rather than the spirit which they expressed. The gothic ſtandard was unfurled as the ſtandard of revolt ; but the spirit for which this ſtandard ſtood was in reality more alien than its rival to the new outlook which was as yet so little aware of its own nature. Having no roots, neo-gothicism, after an exaggerated and ugly blossoming, died a discreditable death, though its descendants yet

[1] *Colloquies on Society*, by Robert Southey.

linger tenaciously among shoddier suburbs and ecclesi-
astical buildings.

The activities of the author of *Vathek* at Fonthill
epitomise the failure of this grotesque and flimsy revival.
Finding in the house which he inherited nothing to
gratify the wild ardours of his romantic imagination, he
instructed his architect to design " an ornamental build-
ing which should have the appearance of a convent, be
partly in ruins, and yet contain some weatherproof
apartments."[1]    Upon the construction of such an
edifice five hundred workmen laboured without ceasing.
At night their efforts were illumined by many torches.
Above an immense gothic palace rose a tower three
hundred feet in height.   But this fantastic structure fell
to the ground, and William Beckford was left con-
templating his too completely achieved ruin in the
torchlight.

Although the gothic standard did not for long
flutter above the anti-classic armies, those forces gained
in power year by year.   More permanent standards of
revolt were borne by an irregular succession of men
throughout the nineteenth century.   If the graphic art
of the eighteen-nineties is the final expression of a
protest against industrialism, so also it is the climax of
modern romanticism.   To this twofold climax it owes
its historical importance.   It may be objected that no
period which produced so great a preponderance of
minor and even trivial art can be said to form the climax

[1] *Life and Letters of William Beckford*, by L. Melville.

of two movements so momentous. But to the present writer the more trivial art of that decade resembles the foam and spray which form the crest of a vast, twofold ocean wave which has reached its greatest height.

It is yet too early to do more than indicate a few figures in that succession of artists for whom the Greek ideal of that near and still which is saturated with beauty, to the exclusion of the dynamic and the distant, was not enough. The nature of the struggle differed widely on the two sides of the English Channel. In France the political opportunities afforded by the revolution and the emergence of two classic giants in Jacques-Louis David and Jean-Dominique Ingres, gave to classicism a magnificence, a dignity, and above all a renewed vitality that greatly prolonged its powers of resistance. But there was to be no final staying of the tide. The more powerful was the classic resistance the more urgent became the Impressionist attack. Impressionist, for that had become the label of the group whose aims were the discovery of a new technique and the expression of contemporary reality. The label was fixed upon the group round Manet about as fortuitously as were Whig, Tory, Jacobin, or Bolshevik upon the opinions and outlook they represent.

The Emperor Napoleon III, with one of those liberal gestures which were characteristic of him, suggested that the paintings of this school, which had all been rejected by the Salon Jury of 1863, should be hung together in a separate room. The public, at this time

very resentful of such revolutionary innovations, chose
—as resentful crowds will—an especial object for its
derision. The chosen object was Claude Monet's sunset
canvas entitled *Impressions*. This picture thus gave its
name to what was soon to become the greatest of all
modern schools of painting, and one which influenced
profoundly the English painters of the eighteen-nineties.

The Impressionists' vision of the material world was
diametrically opposed to the classic. The Greeks
kept close whenever they could to what was immediate,
palpable, and bodily, and when they could not, endowed
even abstract qualities with bodies. The impressionists
conceived of even the most material objects not so
much as bodies as light-resistances in space. In a view of
the world in which light is the ultimate and universal
material reality, material objects possess no outline and
no colour save what light gives them (for if the light is
put out both colour and outline vanish). The distinction
between one object and another is held to be arbitrary
and conventional, for in nature everything is one and
indistinguishable. (It is this view which later led
artists to paint purely abstract pictures, bereft of those
conventionalisations of objects which makes them easily
recognisable.) Such distinctions once made invalid, it
follows that emphasis falls naturally upon colour rather
than line. But colour is itself made by the more or less
rapid vibrations of light upon certain surfaces, which
are in themselves colourless. Therefore the light itself
is always the real subject of an impressionist picture.

## et des Romains?

It was therefore to be expected that this school's characteristic contribution towards a new technique should have been concerned with the treatment of light. Upon the theory that the colours of the spectrum are recomposed in everything we see, they based their exclusive use of these seven colours, with the addition of black and white. These solar tones were not to be mixed upon the palette, but placed in *juxtaposition* upon the canvas, so that the rays of each of them should appear to blend when seen from a certain distance and have upon the beholder the effect of sunlight itself.

The Impressionists have often been attacked upon the ground that they were not artists so much as scientific photographers. If the methods of the early Impressionists were scientific, their aims assuredly were not. These were in fact typical of what is most significant in modern art : to reveal a view of life, a vision of the universe, by concentration of the uttermost intensity upon a limited theme. Moved by a like aim, Anton Chekhov, most consummate of modern writers, reveals to us in a flash the dreariness of an entire life by describing a cigarette end floating round in a slop-pail. Indeed it is from the scientific side that the Impressionists are more readily assailable. Arrived at the moment when Science had entered upon its most triumphant phase (Darwin had published his *Origin of Species* not much more than a decade before the Parisian public had labelled Monet and his friends " impressionists ") the theory of the spectrum was not free from the pseudo-

57

scientific facility which characterised so large a proportion of the thought of the time. Also, not being so accustomed as their descendants to the rapidity with which scientific theories evolve, the Impressionists themselves, although by no means enslaved by the idea of the spectral palette, did regard it with a scrupulousness which to a later generation appears pedantic.

The fallacy inherent in the theory of the spectral palette is sufficiently obvious. If the aim of the artist were to paint the spectrum, such a palette would be adequate. But their aim was confessedly to paint nature, that is, not the rays of light in their pristine purity as intercepted in a lens, but those subject to every degree of variation by reflection and absorbtion.

Meanwhile, French literature was in a ferment of protest against the drab uniformity engendered by the industrial system. Its aim became the expression of the character and the aspirations of the individual in contemptuous opposition to the conventions of the mass. This was its predominant theme. But where the masters had been the just and courageous champions of individual character, their disciples became mere advocates of a somewhat ludicrous over-emphasis upon personal eccentricity.

To adopt a pose is for the average man a simple thing compared with holding a philosophy with understanding, or a conviction with intelligence. And so the young Englishmen studying during those years in Paris adopted the manners of genius, and transferred them presently

*et des Romains?*

to our shores. Such is, in short, the pedigree of that
pose which, when assumed by men of sufficient character
and ability to support it, becomes a thing of diverting
brilliance and audacity. But when less gifted men seek
to assume the *rôle*, it becomes for the Englishman, if not
for all the world, the least endearing form of posturing.

And so when the great had died, and their *mots* been
worn a little thin by repetition, and there only remained
the others, attempting to conceal the nullity of their minds
behind the now somewhat tattered mantle, a revulsion
set in. There was no change of heart, but a change of
pose; and that combination of genius and man of
fashion, who punctuated the exquisite pageant of his
days with apt epigram and polished retort, ceased sud-
denly to be the glass of fashion and the mould of form
for the younger England. And it has never returned,
for fashions can only come again when they are all but
forgotten. Even if other conditions were favourable to
such a return, the fame and notoriety of the eighteen-
nineties would prove far too powerful a barrier against
the acceptance or even tolerance of its ideal. And should
England forget that epoch the rest of the world, which
cherishes the memories of it with a persistency which to
most Englishmen appears so singular, could hardly
resist the temptation to remind her of it.

Scarcely less important than its demand for personality
was the growing passion revealed in the French literature
of the time for a more literal interpretation of truth than
had hitherto been artistically envisaged. Incensed by

59

the prudish criticism with which it was received, its passion for literal truth grew rapidly into a steady preference for that aspect of it which the ostriches of our kind delight in apostrophising as the sordid and the disgusting. From this development arose the silly, oft-heard plaint : " But why can't they write about something *beautiful ?* "

Art and literature in France had been seeking ever since the decline of the romantic movement, with a constantly increasing intensity, for a less conventionalised vision of reality. The search is implicit in the painting of Courbet, Corot, and the Barbizon school; in the writings of Flaubert, Maupassant, and Zola it reached a culmination full of power and magnificence. In the work of these three, and most markedly of all in Zola's, are evidences of that quickening of sympathy and understanding of contemporary life. There is, mingling with bitter resentment against the mean uniformity of life dominated by an industrial system, a desire to grasp and to express the full significance of it. And the two motives did not clash; for since the shattering of the classic belief that art should depict only what is in itself æsthetically beautiful, artists claimed the right to draw beauty, even if it were of a different kind, out of anything under the sun. Indeed, given that which was most vital in life, and therefore the best subject-matter for the vital artist, had become outwardly ugly, and given also that the vitality of art did persist, such a change of outlook was inevitable.

## *et des Romains?*

And so Zola, without troubling to ask himself whether the outward aspect of it was such as to merit description on æsthetic grounds, immersed himself in his own age with all the passion with which his romantic predecessors had attempted to run away from theirs. As a result of the publication of the fruits of his experience, it began to transpire that great cities, factories, railways, and steamships and the civilisation of which they were the chief expression, were hostile neither to romance nor to beauty, to the kind of beauty at any rate which is perceptible by the modern vision. The essential quality of this kind of vision lies in the perception even more than in the object perceived. And as the study of psychology continually enhances the general realisation of the importance of the subjective outlook, it naturally follows that the contemporary vision grows increasingly subjective also.

So in the hands of Zola the modern world became not only understandable but possessed of a terrible, a new, a fascinating beauty.

Much of this spirit also made itself felt upon this side of the Channel. Although it did exert upon the artists of the 'nineties an influence by no means inconsiderable, it found far stronger expression in the writings of those novelists the spirit of whose works differed essentially for that reason so widely from theirs. Of these the most important were George Moore, H. G. Wells, and Arnold Bennett.

England had yet one more lesson to learn from France.

# Qui nous delivera des Grecs

Strictly speaking, it was a lesson in literary form, but as the artists of the 'nineties learned at least as much from the literature of France as from her painting, it may be mentioned without irrelevance. It has been earlier noticed that in the vision of our time the relative importance of the object perceived has diminished, while that of the manner of its perception has correspondingly increased. Translated into terms of painting, writing or any other art, this means (as seeing is only a preliminary to execution) that style is becoming more important than subject. Although English writers have produced a literature as great as any that exists, they have but rarely attempted to treat writing as a conscious art, with secrets to be fathomed and a definite technique to be mastered. The French, on the other hand, had for a considerable time so regarded it, and had evolved a prose which for precision of expression is unsurpassed in any modern language. Furthermore, it has been so consistently developed with so conscious and sure an artistry that it cannot be used in the most prosaic sense without revealing this quality.

What, then, could be more natural than that England, suddenly and strongly influenced by a realisation of the importance of style, should turn towards that country where style had been brought to its highest pitch of perfection? Thus the writings of Flaubert and Baudelaire and Gautier became objects of the deepest admiration on this side of the Channel. The majority of the artists of the 'nineties fervently shared this feeling, with

62

the result that such tendencies towards ſtylisation as were inherent in each were greatly enhanced.

All these Gallic influences had been making themselves felt for several decades before 1890. For example, in Swinburne's *Poems and Ballads*, which was published in 1866, is clearly discernible the influence of Baudelaire's *Les Fleurs du Mal*, which had appeared nine years earlier. The flow of ideas from France to England had since the eighteenth century been conſtant, as had been the movement in the contrary direction. But in the final decade of the nineteenth, English intellectual society was affected as never before by French forms and ſtandards. Besides the foreign influences which played so large a part in the formation of the outlook which lent cohesion to the group of artiſts with whom we are concerned, there exiſted a succession—sporadic, incomplete, but almoſt purely native—of which it was the direct inheritor. As no successions have any source save Adam, in describing them it is necessary to choose arbitrarily some point from which they may conveniently be said to ſtart. The one of which the men of the 'nineties were the successors may be conveniently traced back to none other than William Blake.

His boyhood fell in those years when English classicism was finding its moſt admirable expression under the diſtinguished and all-powerful guidance of Sir Joshua Reynolds. The individualism and self-reliance of Blake's attitude has been aptly contraſted with that same blend of opportunism with tradition which conſtituted Sir

# Qui nous delivera des Grecs

Joshua's. In his *History of Modern Painting*, Richard Muther thus compares them : " Painting, as Reynolds underſtood it, corresponded to the needs of the day ; and Blake worked throughout his life without other thanks than the appreciation of a few superior and solitary minds."

In the art of Blake, as in the art of Wagner, may be seen the sublimeſt expression of the modern soul. In both the sense of the infinite and the dynamic is ever present. Submission to classic tradition and classic form would have caused either of them to fall short of what they actually achieved. So profound is the difference between the classic and the modern souls, and yet so sublime are both, that it only matters to the greateſt of mankind into the sphere of which they happen to fall. Smaller men, in whichever of the two directions their natures may cause them to tend, have ample space in either to fulfil themselves. But submission by Blake and Wagner to the spirit of classicism would have limited their achievement. Conversely, neither Plato nor Ariſtotle, were they born again into the modern world, could equal that which they achieved in an age dominated and suffused with the classic spirit.

The reader may judge from the marginal notes which he made in a copy which the British Museum possesses of Reynolds' *Discourses* what was Blake's attitude towards the man who summed up in his own person all that was moſt important in English classical painting.

The work of the man whose fate it was to carry on the

tradition of fervid imagination and lonely individualism, was far from being of the first importance. Nor was he a pupil of Blake's, but nevertheless the quality of his aspiration marks him clearly as his successor. David Scott possessed all the morbidity which, absent from both the work and character of Blake, showed itself persistently during the 'nineties. His mind, from childhood upwards, was constantly obsessed by the thought of death, and it is recorded with reference to this preoccupation that as a boy he once wrapped himself in a sheet to play at being a ghost, and was so much terrified by his own reflection in a mirror that he fainted, and suffered afterwards from a nervous fever. The set of drawings which he made many years later for *The Pilgrim's Progress* shows how strongly this morbidity persisted even in his maturity. Possessed by imaginings far more immense and turbulent and swiftly-hurrying than could find expression through a technique by comparison so inadequate, David Scott stands like a ruin of something potentially vast yet actually unfulfilled and pathetic, between Blake and Rossetti.

That a direct line passed from Blake through Scott to himself was not perceived by Rossetti. Two references contained in his letters to his precursor seem to support the view that he held him in ridicule. Writing to his mother on the 20th of June, 1853, he says : " I occupy my time chiefly in chaffing Scott (William Bell Scott, the artist's brother and a great friend of the Rossetti family) about his brother David's works, and made a grand

allegorical design yesterday in that worthy's style, which I declared was as fine as anything of his, which Scott, I believe, considers to be really a grand work, though I myself do not understand it."

He expressed himself with even greater levity in a letter bearing the same date to his brother, William Michael Rossetti. Here he simply declares that " David Scott is a tremendous lark." His brother is, however—in the memoir he appended to his collected edition of Gabriel's letters—at pains to correct what seemed to him to give a false impression. " Gabriel's observation that he was ' a tremendous lark' represents his opinion only in a certain sense. He saw the singularities and aberrations of David Scott's genius, but really admired it in a high degree."

Blake himself was a far greater source of inspiration. Being a poet, Rossetti was able to wander into the domain of painting with the same sense of wonder, the same freedom from those conventions which had made of that art something so smug and stuffy. In the freshness of his vision he resembled the impressionists, who across the water were fighting the same battle as himself. There the resemblance ended. McColl exactly perceived the nature of the gulf which divided them when he wrote of Rossetti as being " blind to tone, and seeing in line, with fields of colour raised to a trance-brilliancy, he brought up sharply to the surface of his painting all the web of outline that modern tone composition had made secondary and implicit."[1]

[1] *Nineteenth Century Art.*

## et des Romains?

The famous Pre-Raphaelite brotherhood of 1848, in which he was associated with Millais and Hunt, quickly dissolved because the laſt two were tending towards a realism quite alien to Rossetti's nature. It was not until eight years later that his conneƈtion with Burne-Jones and Morris and Hughes precipitated the ferment which, coupled with a sudden intensifying of the French influences outlined earlier, was direƈtly responsible for the peculiarly individual quality which pervaded the entire atmosphere in which the men of the 'nineties moved. Compelling as Morris and Burne-Jones were, it was Rossetti who contributed moſt powerfully towards it : Rossetti with his melting and exotic sensibility, his passionate and morbid imagination which worked beſt by night. These qualities made him the dominating English anceſtor of the men of the 'nineties, no less than they made him—with his independence of conventional forms, whether traditional and contemporary, and the solitary quality of his mind—the true descendant of Blake.

Before this union came about, Pre-Raphaelite influence unaided produced two notable results, each of which considerably affeƈted the charaƈter of the 'nineties. These were the revivals of book illuſtration and crafts-manship. The effeƈt of the firſt upon the artiſts of that decade was that they found ready to hand a medium already brought to a high ſtate of perfeƈtion, admirably suited to the literary and minor nature of the greater part of their inspiration ; while the second encouraged many of them to decorate their own houses with *objets*

67

*d'art* of the newer craftsmanship, giving them thereby an individuality which they could not otherwise have possessed. While William Morris was attempting to transform the outward aspect of everyday life by designing and making chintzes, wallpapers, dresses, and furniture, the new school of illustrators were portraying with a new and romantic vision the stilted and drab mid-victorian world. The earthly passions of which a prudish convention forbade mention by the written word, were insistently hinted at in the illustrations with a wistful and exquisite sentimentality.

The relation of this school to the Pre-Raphaelites has been described by Laurence Housman in his essay on Arthur Boyd Houghton :

> In the strictest circle of the brotherhood itself (he wrote) there had been something of a literary element, at times so evident that 'bookish' might also be used as the word for conveying its flavour. These new men—Houghton and the rest—made a closer alliance with life, with the facts and passions of everyday existence, and threw themselves with personal enthusiasm into an idyllic rendering of the Victorian age of crinolines, breaking away from the somewhat cramped and cloistral point of view which had marked the earlier days of the movement.

By the time the last decade of the nineteenth century was reached, the reaction against the victorian convention of respectability had assumed such proportions that mere suggestion that it concealed passions in all their brutality and ugliness had become utterly

inadequate, and an idyllic rendering something akin to treachery to *le mouvement*, to those superior persons for whom the mask no longer existed. To the men of the 'nineties their alternate baiting and defiance of Mrs. Grundy appeared so important that a brief enquiry into the orgin and development of the cult to which she has given her name becomes a necessity.

History records few changes more complete than that which overcame the outward aspect of English public life between the reigns of George III and Victoria. An example or two will suffice to remind the reader of the nature of public morality under the earlier monarch. Lord Weymouth, Carteret's grandson, having devoted the earlier part of his life exclusively to the bottle and to gambling (at which pastime he was most unlucky) found himself without fortune, credit, or honour, and was on the point of leaving the country. But his family begged him, as a last resource, to try public life. The Lord Lieutenancy of Ireland happened to fall vacant, and the bankrupt drunkard was appointed. There was some resentment in Dublin and the appointment was rescinded. But as a consolation prize he was made Secretary of State for the Northern Department, and became responsible not only for the entire internal administration of the Kingdom but also to a great extent for the conduct of its Foreign Affairs. It is recorded that he did not pay his new duties the compliment of making the very slightest alteration in his habits. He still boozed till daylight and dozed into the afternoon.

# Qui nous delivera des Grecs

Sir George Trevelyan, who describes in somewhat greater detail the doings of Lord Weymouth in *The Early History of Charles James Fox*, there makes an illuminating reference to an episode in the career of his successor to the Secretaryship of State for the Northern Department. The incident, with the absence of consequences to the chief figure, and the attitude of the public, gives a vivid impression of the moral tone of Georgian politics. Of the Earl of Sandwich he writes :

> Nothing substantially injured him in the estimation of his countrymen, because no possible revelation could make them think worse of him than they already thought. When he was advanced in age, and at the head of what was just then the most important branch of the public service, he was involved in one of those tragedies of the police court, by means of which the retribution of publicity sometimes overtakes the voluptuary who imagines that his wealth has fenced him securely from the consequences of his sin. But no coroner's inquest, no cross-examination at the Old Bailey, could elicit anything which could add a shade to such a character. The blood had been washed from the steps of the theatre ; the gallows had been erected and taken down ; the poor creature, who was the object of a murderous rivalry, was quiet in her grave ; and the noble Earl was still at the Admiralty giving his unhonoured name to the discoveries of our most celebrated navigator, and fitting out expeditions which might reduce the Puritans of New England and the Quakers of Philadelphia to the necessity of contributing to the taxes out of which he replenished his cellar and his seraglio.

A couple of sentences from a letter from Horace

Walpole to Horace Mann give the necessary completeness to the picture :

> The poor assassin (the letter runs) was executed yesterday. The same day Charles Fox moved for the removal of Lord Sandwich, but was beaten by a large majority, for in Parliament the Ministers can still gain victories.

This episode gives to the actions of another of the King's Ministers in appearing at Ascot races and the Opera with a woman whom he had " picked up " in the street, the appearance of a mere piece of rakish effrontery. The Duke of Grafton's whim did in fact arouse unfavourable comment, but he continued unmoved in the position of first servant of the Crown.

But within a few decades of these and ten thousand other like episodes the drab, even, victorian dust had settled upon the whole of English life. So entirely had the tone of the outward conduct of life changed, that public opinion soon showed itself bitterly and brutally hostile towards not only conduct smacking, however slightly, of irregularity, but also towards any attempts, however sincere, to deal honestly with any problem which violated the new convention of respectability.

In small and exclusive societies with easily recognisable frontiers, hypocrisy is rarely a prevailing vice. Members of such societies have, on the contrary, generally been content to show themselves in their true colours. The English aristocracy in the eighteenth century illustrated this rule with an audacity and consistency which shocked

its immediate descendants. The following passage from
*The Early History of Charles James Fox* shows clearly
enough that to the eighteenth century man of fashion
hypocrisy would have been futile and ludicrous.

> There was no use in trying to impose upon people who had
> been his schoolfellows at Eton, his brother officers in the
> Guards, his colleagues in Parliament, his partners at whist, his
> cronies at the club, his partners at a hundred revels. Every
> friend with whom he lived was acquainted with every cir-
> cumstance of his career, and every turn in his affairs—who had
> jilted him, and who had schemed for him ; how many thousands
> a year had been allotted him by his father, and how many
> hundreds he allowed his son ; how much of his rent-roll was
> mortgaged, and how much wood was left uncut in his planta-
> tions ; what chance he had of getting heard at two in the
> morning in the House of Commons, and what influence he
> possessed over the corporation of his neighbouring borough.
> Unable to dazzle those for whose good opinion he cared, it only
> remained for him to amuse them. . . .

Such general omniscience resulted in a phenomenon
which a little later in the same spirited and well-balanced
work is concisely summed up :

> . . . men of age and standing, of strong mental powers and
> refined cultivation, lived openly, shamelessly and habitually in
> the face of all England, as no one who had any care for his
> reputation would now live during a single fortnight of the year
> at Monaco.

In a few decades the conditions which rendered possible
such a phenomenon had radically changed. Political

power had begun to pass from the hands of the aristo-
cratic oligarchy into those of the great industrials and
merchants. These, whatever the nature of their private
lives, came for a variety of causes to demand, and to be
identified with, a standard of conduct in public life
infinitely more austere than that displayed by their pre-
decessors. The average historian in accounting for this
circumstance points to the evangelical or nonconformist
nature of the religious views held by a great majority of
the new men, and to a certain popular revulsion against
a public standard of conduct at once repellent and
expensive. But both these causes were in fact only
contributory and incidental. Persons holding evan-
gelical views have been known, after tasting political
power, not only to lead outrageous lives, but to flaunt
their infamy in public. No mere change in religious
form is sufficient to alter by itself the habits of one man
—far less revolutionise the standard of conduct in a
great political system. In any case, nonconformists did
not enter active politics in considerable numbers until
the change had already been brought about.

Nor do popular revulsions against the licentiousness
and extravagance of governing classes in general effect
more than the most superficial alterations. To account
for a change so real as that which occurred between the
georgian and victorian eras it is necessary to look far
beyond a mere increase in the powers of one form of
religion over another closely resembling it, or such a
transitory event as a spasm of popular indignation. It

is not difficult to be ironical at the expense of the *dramatis personæ* of a transition taking place in so short a time, indeed within the span of many of their lives, between debauchery shameless and avowed, and prudery even more destructive of moral integrity. We may well laugh at the hypocrisy of statesmen who at a tender age lived openly with prostitutes whose acquaintance they made in the streets, but who, by middle life had reached the conclusion that sex, for instance, is a subject which (apart from marriage) did not, for decent people—such as themselves—exist at all. As the most universally enthralling subject was written down as unmentionable by a society whose older members had, with few exceptions, spent their early lives whoring, the steadily growing public passion for all its manifestations, leading up to the culminating intolerance of all restraint which characterises our own day, was as inevitable as the daily emergence of the sun above the eastern horizon. Such worshipping of hypocrisy is merely characteristic of the contortion to which human beings in the mass invariably subject the ideals with which the nobler of their kind present them.

This brings us to the cause which contributed more than the rest combined to bring about the change. Towards the end of the eighteenth century the industrial revolution had already put potential political supremacy into the hands of the great industrials and merchants, but with the aristocratic oligarchs still at the head of affairs it was difficult to translate this potentiality

into actuality. Even when the electoral system had been placed upon a broader basis there appeared no compelling reason why the new men should be elected rather than the old. It seemed at first as though there were nothing which the capitalists could contribute to public life which had not been or could not be given by the aristo-crats. What was needed was something which could be thus offered.

Popular disgust with the dissoluteness and corruption of the governing clique combined with the provincial narrowness of the new men of business to produce the new ideal which was to be set before the nation. By this ideal of public decency, public integrity and public zeal the new rulers of England often honestly and usually unconsciously sought to justify themselves against the prestige, tradition, and hereditary rights of the old. The ideal was tragically overdue. The oligarchy was too deeply compromised and too insensitive to popular feeling to fulfil it, and the newer and cruder men used it as a lever to lift themselves into power.

The earlier days of this struggle represented a con-scious attempt to substitute character and conduct for birth. But it was destined to meet the fate which waits inevitably for every puritanical reaction: respect for fine conduct dwindled with alarming rapidity into mere adulation of respectability. Respectability was, in fact, an even more convenient suit in which the new might outbid the old in the favour of the increasingly powerful electorate, being as safe as it was plentiful. For the

electorate had had its sense of individuality and independence almoſt as completely degraded as its sense of beauty by the induſtrial revolution, and it came to demand with greater and greater insiſtence the universal application of the dreary convention in which it saw its own ideal moſt clearly mirrored.

In a world in which machinery is providing ſtandardised boots for the people's feet and ſtandardised houses to shelter them, there is surely nothing surprising in the faſt that firſt the press and then the wireless and the cinematograph have provided them with a ſtandard public opinion incorporating a ſtandard code of morality. The majority of English painters and writers have acquiesced in this convention with a docility which is difficult to underſtand, since respeſtability is so compromising a bedfellow for any art which claims to be an aſt of homage to truth. By obtaining their effeſts by an infinite number of subtle variations within the ſtriſtly circumscribed fields allowed them, by hint and suggeſtion where direſt ſtatement would have opened the sluice-gates of public wrath, many rays of the light of truth were permitted thus almoſt secretly to illuminate the viſtorian scene.

The slyeſt of Truth's lovers was William Makepeace Thackeray, whose *Vanity Fair* is a supreme achievement of clandeſtine wooing. But he was, for all his sprightly satire, an acquiescent soul, ever ready not only to accept and rejoice in the conventions and diſtinſtions which governed social life in his days, but to regard them as

things of far greater permanence and significance than they were. The graceful and charming snobbishness with which he regarded a peer of the realm was no less obvious in his attitude towards moral convention. Few others were fortunate enough to be the possessors of temperaments so nicely adapted to enable them to portray contemporary life with a great degree of truth without disrespect to the idol of respectability. Shelley and Byron, neither of whom possessed Thackeray's gift for accepting the conventions governing life and literature, protested passionately against the idol; but both died young and outcasts from their native land. The Pre-Raphaelites, although far less revolutionary, by the force of their religious fervour, even more than the sensuality of much of their work, aroused resentment almost as sharp.

The grosser part of public opinion, regarding these last, was not inaccurately voiced by Charles Dickens, when he wrote in *Household Words* the following description of Millais' picture: *Christ in the Home of His Parents:*

> In the foreground of the carpenter's shop is a hideous, wry-necked, blubbering, red-haired boy in a nightgown, who appears to have received a poke playing in an adjacent gutter, and to be holding up for the contemplation of a kneeling woman, so horrible in her ugliness that (supposing it were possible for any human creature to exist for a moment with that dislocated throat) she would stand out from the rest of the company as a monster in the vilest cabaret in France or the lowest gin shop in England.

77

## Qui nous delivera des Grecs

To this bitter feud with the idolaters of respectability the men of the 'nineties were also heirs. The most famous among them tempted providence with such wanton recklessness that the idolaters were able to destroy him. Despite the contrary effect produced by an immediate and violent reaction in its favour, the cause of respectability was dying, and the strictures of the prosecution at the Wilde trial and the jeers of the mob which greeted the prisoner at Clapham Junction were the appropriate swan-songs of a mood which is not the less distasteful for having been so abundantly justified.

The influence of the idol of respectability is the last of the forces which have gone to mould the collective nature of the artists belonging to the group which has, quite fortuitously, been labelled " of the 'nineties ". The ineptitude of such a title may be asserted upon two different grounds. It carries with it firstly the implication that the members of the group which it seeks to describe exercised either the dominating or character- istic influence upon the epoch in which they lived : secondly, that the epoch in question was the ultimate decade of the nineteenth century. Both implications are misleading. While the group did number among its members some whose work was of very great importance, they in no sense dominated the scene ; nor were they especially characteristic of it. Indeed, protesting with the spirit which they inevitably displayed against the direction which contemporary civilisation had taken, they remained a small, somewhat isolated and reactionary fraternity.

## et des Romains?

The chronological implication is hardly less inaccurate. In as far as the period had, for a limited group, a definite existence, it was well under way by the middle 'eighties under the leadership of Whistler and Wilde. But although it is not easy to ascribe the year of its birth with accuracy, the date of its demise is patent to all the world. It was suddenly submerged beneath a wave of disproportionate and grossly expressed popular rage, when on May the 25th, 1895, the celebrated dramatist whose career has been rightly declared the epitome of the whole decade, was sentenced to two years' imprisonment with hard labour.

There is yet a further misleading implication made by the label " of the 'nineties ", which is that the group to which it has adhered possessed a conscious solidarity. This was not in fact the case. There existed at the time, among scores of other themes, certain particular moods, aspirations, and reactions, the history of which has here been briefly related. Although these were not without effect upon all artists then living, there were some in whose work they found an especially natural and complete expression. Many of these artists knew, and consequently influenced, each other. Thus far, and thus far only, were the men of the 'nineties a corporate group. As a body of brilliant young men, unique in their wickedness as in their dazzling talents, separated by both from the rest of the world, the " 'nineties " never existed. Yet such is the legend.

How, it may well be asked, can a myth so insulting

79

to the moſt ordinary intelligence have come into exiſt-ence and eſtablished itself so securely within so brief a span of time? The answer is to be found in the writings of a group of journaliſts. The sole claim of these persons upon the world's notice is their contaċts with certain celebrated artiſts and writers who were working during the laſt decade of the laſt century. These contaċts they have never ceased from recounting, and in the fullness of time (as dead men tell no tales) proximity has ripened into acquaintance and acquaintance into friend-ship, friendship often into exclusive friendship. Had these journaliſts been men possessing integrity and insight into charaċter, their voluminous reminiscences would have been invaluable to the ſtudent of the period and fascinating reading for the layman. Inſtead, they have chosen to paint an improbable and somewhat lurid scene, which had no being save in their imaginations: they have chosen to present to the cold ſtare of a genera-tion already sceptical with regard to its seniors the engaging speċtacle of a crowd of elderly gossips scramb-ling, without dignity and without honesty, after the diſtinċtion of having been the firſt to discover the genius of so-and-so, the sole recipient of this momentous decision, the sole audience at the launching of that epigram.

The only coherent group relating to the 'nineties was composed of these hangers-on. And they were a curiously composed crowd. Bitter rivals for the friend-ships, and loquacious squabblers over the confidences,

of the celebrated dead, they yet possessed the sense as well as the requisite impudence to pretend that this brilliant, naughty society—of which no one had heard until they, its historians, nay, its principal surviving members, condescended to reveal its secrets to the world—actually did exist. The nature of these revelations may be easily gauged by a comparison between them.

The struttings and posturings of these self-styled survivors from a better and a naughtier world bear a curious resemblance to the gestures of the extremer sort of calvinists who, sure of their salvation, linger with impatient arrogance in this life awaiting the divine call to the next.

The legend still persists concerning a decade which blossomed with the flame-like suddenness of an exotic flower, and a generation of young men who arrived with the radiance and detachment of shooting-stars, in whom the youth and wickedness and genius of all the ages was epitomised. It has been created with so little art that it persists, not as history but as a legend, and furthermore, as a legend of which the world has grown weary. It is, not unnaturally, no more believed than are the episodes of Greek mythology. But while the thoughts and deeds of the serene gods of Olympus are a delight to every period, the garish eccentricities and clevernesses attributed to the men of the 'nineties neither amuse nor delight anyone.

I have been provoked in this essay, to attempt, despite

my manifest feebleness of equipment for such a task, to hint at the historical actuality which the legend has distorted, to show that the work and the outlook of the artists of the 'nineties were intimately related to the profoundest realities governing their time, and the men themselves the direct heirs to the traditions of centuries. The dominating factors in the composition of the mind of this epoch have been outlined with such emphasis not so much to challenge the improbable and self-glorifying fiction of a company of gossips, but to call in question the attitude of the generality of art critics and art historians towards their subject. These men, with singularly few exceptions, labour under a delusion regarding the very basis of art. When writing about any artist they find it necessary to rig him up with a genealogical table displaying his artistic pedigree. The vision of this older or contemporary artist, the technique of that one, some idiosyncrasy of a third, are all shown to have played their parts as ancestors. Thus the fundamental condition of great art utterly escapes notice— which is that its origins are not to be found in other arts but in life itself.

The activities of these critics and historians, even when pursued, as they are not infrequently, with the greatest power and learning, are entirely directed towards the elucidation of the incidental in place of the essential, of the mere instrument instead of the inspiration which it serves. Truly to a great extent not only the sources but the nature of inspiration remain hidden. Its nature

is none the less visibly and profoundly modified not by æsthetic considerations but by the forces which mould the age in which the artist happens to live.

Although the precise relation of these forces with the arts lies outside the scope of this essay, the foregoing criticism of the prevalent failure among art critics to recognise the essential forces determining the nature of their subject may explain the persistent if brief attempt on my part to present the 'nineties with a background in which purely æsthetic considerations have little place. It may even go some way towards justifying a point of view which sees in the eighteen-nineties not a period of the first artistic importance but the supremely illuminating culmination of certain positive movements and reactions which have made and are still making integral modifications in the structure of our civilisation. In such a vision it is inevitable that the influence of the industrial revolution, the incompatibility of the free development of the modern mind with the retention of the Classic idea, the revolt against convention following the degeneration of respect for character into adulation of respectability, the consequent extension of the field of all art so as to include what had before been unmention able—should all loom larger than the influence of one artist upon another. For these, although in themselves impermanent, are the transitory manifestations of the stuff of which history itself is made.

# PART II
## THE PLAYERS

# Chapter Three

## *Whistler*

ART is a product of superfluity. Directly primitive men had achieved a state when their energies were no longer absorbed solely by the struggle to obtain and to preserve the elementary necessities of existence, the time destined for the satisfaction of one of the deepest instincts of certain among them was no longer distant. Once they were assured, by either individual prowess or power of combination, of a supply of food and some degree of personal security even for short periods, something entered into their lives which has been an essential condition for the nurturing and growth of all the arts and the sciences. The leisure which such a state assured to them was of a very different kind from the fitful hours of rest which they had hitherto enjoyed. During those dangerous and uncertain periods it had been necessary for them to preserve the strength and energy upon which depended their very lives. The opportunity for doing nothing at times, untroubled by immediate apprehensions of want or danger, was an entirely new experience. In such circumstances the instinct to decorate must quickly have asserted itself.

This desire, like most others of equal force, is found

in varying degrees among moſt human beings. It shows itself in its moſt rudimentary and negative form in the preference of the average man for a certain symmetry and order in his own environment ; in a rarer, more positive and more suſtained form in the activity of the craftsman ; at its rareſt in the creative passion of the artiſt worthy of the name. And societies, even the moſt primitive of them, underſtanding the craftsman little and the great artiſt not at all, made use of both. For the activities of artiſt and craftsman, despite this lack of underſtanding, doubtless appealed from the very firſt to the moſt rudimentary manifeſtation of the decorative inſtinct which the ordinary man is seldom without. Thus while the great artiſt has often been unrecognised if not actually persecuted, the activities of artiſts in general have met in all ages with a large measure of approval and respect.

Nor need the hoſtility which the great artiſt has evoked give cause for surprise. For the time is yet to come when the emergence of powerful individuality in any other guise than that of soldier or ſtatesman shall cease to be a direct challenge to the herd inſtinct upon which the edifice of human society is built.

But the artiſt and the craftsman depended for their livelihood upon something more subſtantial than a general vague respect for their vocation. The craftsman because he made as well as decorated the objects of daily use, so that the people who used them had no choice ; the artiſt because his power of creating heroes out of

mere princes and warriors, of exhibiting the truths
buried in abstruse doctrine vividly to the people, and
to these last the splendour of their rulers. And society
has never, down to the very threshold of our own times,
been slow to harness to its own needs the powers of the
artist and the craftsman. Thus in Western Europe in
recent times, first by universal Church, then by national
monarchy, and finally by oligarchic aristocracy, were
they kept in constant employment. So constantly were
their services called for, and so exigently used, that they
had little leisure and indeed little need, to enquire
exactly into the nature of their calling. They were
happy in their work, and that work was urgently needed.
What need then for analyses, for searchings after its
causes and effects?

The coming of industrialism with one blow destroyed
the monopoly used so splendidly by the craftsmen of
the ages, and the last great class of patrons of the artist.
The artists split, as we have seen, into two parts in every
sense unequal. With that section, infinitely the greater
in size and the smaller in achievement, which subscribes
to the philosophy of Wilkie, we have little here to do.
Suffice it to say it attempted to some extent to follow
the artistic tradition in becoming the servant of the
ruling power. Its aim has been acknowledged by Wilkie
with a commendable candour : " To know (he said) the
taste of the public—to learn what will best please the
employer, is, to an artist, the most valuable of all know-
ledge."

# *Whistler*

But the relationship between the industrial democracy
and artists of this kidney, although it may well have
been and continues to be, a happy one, was not un-
naturally productive of fruits of the vilest order. For
upon the one hand stood a creature of degraded taste ;
upon the other a low pander, eager to improve the hour
by lowering still further his employer's sensibility. The
essential demand of such an employer was that a picture
should be thoroughly intelligible to him. Now it is
sufficiently obvious that a democracy as meagrely
equipped by instinct and education for æsthetic appre-
ciation as is our own must necessarily seek other than
æsthetic interest in its pictorial art. Utterly incapable
of perceiving, much less delighting in, form and colour
for their own sakes, it naturally looks for satisfaction
towards another and more easily appreciable quality.
This quality is what is known rather misleadingly as
" literary " interest. A public obsessed by such an
interest demands not that a picture shall make its appeal
through its own intrinsic qualities, but by the poignancy
of its reference to something entirely external to it.

After having been pandered to for half a century, the
arrogant and intolerant insistence of this demand passed
all bounds. Richard Muther contemptuously describes
the British public of that time as being as a matter of
course " accustomed to run their noses into a picture
and find it explained for them by a piece of poetry in
the catalogue. . . . " This was no exaggeration. Any
picture which failed to represent some specific episode,

or failed to present it in the approved fashion—that is to say, by means of an easily comprehensible composition carried to a high degree of finish—was treated, according to the nature of the spectator, with either derision or resentment. The finish required was of the most artificial kind, being nothing more than the presence throughout the whole picture of sharply defined lines and contours.

Formidable forces combined to uphold this attitude towards painting. Of these the most important was the demand of the public for an art which it could understand. In reality it was incapable of understanding any good art as an end in itself, and was only interested in pictures for the sake of the anecdotal interest which could be disengaged from them.

Nor was this perfectly natural desire for the readily comprehensible in itself harmful to the practice of art of the most excellent sort. But the public, the representatives of the new democracy, hitherto unconsulted about æsthetic matters and now well-nigh all-powerful, was eager to do more than exhibit a perfectly natural tendency. It was determined that all art which did not cater for the general taste should not only fail to flourish but fail to exist. In its view of art the public had the support of the critics. Indeed, the attitude of the critics was not unnaturally considerably less enlightened than that of the public itself; for the majority of art critics had already made it their business to flatter the lowest tastes of the public which it is their duty to

enlighten. And so in their support of anecdotalism and fictitious appearance of finish, they gambolled before the public, hoping by forestalling and exceeding its grossest errors to enhance their own popularity.

The critics had one further and somewhat less discreditable reason for their championship of the generally accepted canons of painting. For literary interest in a picture enabled them to find themselves once more in their own domain, and naturalistic finish precluded ambiguity as to the exact identity of the subject portrayed. What the critics were, in a word, concerned with was not the picture, but the subject. Thus their only technical demand was that this subject should be presented as comprehensibly, and therefore as conventionally, as possible.

During the 'eighties three painters, all conforming with the uttermost strictness to the conventional canons, held the centre of the stage. Each of them in his own way perfectly expressed some phase of popular aspiration, satisfied some popular desire. All three were men of talent. Had any of them been nurtured in an environment less warped and tortured they might have attained to a magnitude impossible in victorian England for any but rebels.

Millais, technically the most accomplished of the three, had quickly abandoned the Pre-Raphaelite phase in which he had achieved work of delicacy and originality. The work of Leighton also, who as a youth had shown something more than promise as a draughtsman, withered

into vulgarity under the disintegrating rays of popularity. He rose rather from his accomplishments as a man than as an artist, which miraculously fitted him for public honour. A noble presence, a capacity for brilliant public speaking, a fascinating address, predestined him for the presidency of some institution. A wit used to enumerate the accomplishments and titles of this paragon, and conclude with : " and he paints into the bargain." As this was indeed the case, what could be more natural than that he should preside over the Royal Academy ?

By far the most interesting of the trio was Burne-Jones. Possessed of great powers of design, considerable originality of vision, and a natural distinction of mind and style, he was able to achieve results unapproached by the other two. Thin and vitiated in manner, remote and sentimental in matter as his pictures appear to our generation, there is yet a quality in their serene and dignified sweetness, the ample balance of their design, to which fashion cannot blind us. Despite his qualities, and the influence of Rossetti, Burne-Jones's art, based as it was upon literature, formed part of the prevailing system of æsthetics. The fact that he had earlier been a Pre-Raphaelite and a rebel, served only to make of his final acceptance of this system an added tribute to its prestige.

That for which people, critics, academies, and the great majority of artists stood was approved and defined by Ruskin when he wrote : " Painting, or art generally, as such, with all its technicalities, difficulties and

particular ends, is nothing but a noble and expressive language, invaluable as the vehicle of thought, but by itself nothing."

But what place is there in this philosophy for all that is most precious in painting—for the intrinsic value of design, of colour, the beauties of line and brushwork, independent of the subject portrayed ? In the sublimest art subject and intrinsic beauty both play their parts. By the eighteen-eighties, in England, subject had usurped the rightful and necessary priority of intrinsic beauty, and was suicidally engaged in its own destruction. Precisely how suicidally is shown by the bitter contempt with which anything savouring of subject is treated in the art criticism of a generation later. But the deliverer was at hand.

In Paris the æsthetic canon which governed English art was anathema. Gautier had declared that the perfection of form alone was virtue, Baudelaire had written of his own art : " La poesie . . . n'a pas autre but qu'elle-même."

When in 1862 Whistler settled in London, that city received as a guest an artist who had already in Paris completely absorbed the æsthetic doctrine implicit in those two phrases. There he held it unselfconsciously, in agreement with the intellectual majority : here, such was the reception accorded to it and to his works which were its expression, that " art for art's sake " became a scarlet battle standard, to be continuously flaunted in the empurpled face of John Bull.

# Whistler

Although Whistler was, from the first moment of his residence in London, at pains to display his sense of the odiousness of anecdotalism in painting, his personal interpretation of current doctrine held across the Channel was neither published nor indeed fully and positively developed until many years later. During these early years he confined himself to expressing his attitude in two ways. He attacked the accepted canons in a pugnacious and brilliant fashion in drawing-rooms and studios—which nobody minded save the immediate objects of his witticisms. He adopted, for his own work, a new system of nomenclature, calculated to emphasise its entire independence of subject in the then accepted sense—which raised a veritable tornado. The new nomenclature was adapted from music, the one art in which form and quality inevitably signify everything, and subject nothing. And so his pictures were entitled *symphonies* and *harmonies* and *arrangements* and *nocturnes*. The public, usually quicker to resent than to detect a challenge to its taste, was on this occasion prompt in its recognition of the motives underlying Whistler's choice of titles.

To recall the vehemence of the clamour of which these pictures and their names were the cause, it is worth while quoting some of the comments of the Press. Whistler himself took a bitter pleasure in collecting, and occasionally even in re-publishing, the more insulting attacks made upon his works by the art critics. The phraseology of the author of *The Stones of Venice* lends

95

a measure of dignity to his definition of the function of art already quoted. But the passages which follow illuminate a somewhat less noble aspect of the body of opinion of which Ruskin was the most reputable spokesman :

> Under the same roof with Mr. Whistler's strange productions, is the collection of animal paintings done for the proprietors of the *Graphic*, and very refreshing it is to turn into this agreeably lighted room and rest on comfortable settees whilst looking at *Mother Hubbard's Dog* or the sweet little pussy-cats in the *Happy Family*.
>
> *Liverpool Courier.*

> His Nocturne in Blue and Gold, No. 3, might have been called, with a similar confusion of terms : " A Farce in Moonshine, with half-a-dozen dots."—*Life*.

> Some figure pieces, which this artist exhibits as " harmonies ", in this, in that, or the other, being as they are, mere rubs-in of colour, have no claim to be regarded as pictures.—*Scotsman*.

> In Mr. Whistler's productions one might safely say there is no culture.—*Athenaeum*.

> We note his predilections for dinginess and dirt.
>
> *Weekly Press.*

> We protest against those foppish airs and affectations by which Mr. Whistler impresses on us his contempt for public opinion. In landscape he contributes what he persists in calling a Nocturne in " Blue and Silver " and a Nocturne in " Black and Gold " which is a mere insult to the intelligence of his admirers. It is very difficult to believe that Mr. Whistler is not openly laughing at us.—*Pall Mall Gazette*.

And crowning all was Ruskin's celebrated attack :

> For Mr. Whistler's own sake, no less than for the protection of the purchaser, Sir Coutts Lindsay ought not to have admitted works into the gallery in which the ill-educated conceit of the artist so nearly approached the aspect of wilful imposture. I have seen, and heard, much of Cockney impudence before now, but never expected to hear a coxcomb ask two hundred guineas for flinging a pot of paint in the public's face.

The object of this onslaught was a nocturne, representing on a night of utter blackness the brilliance of fireworks in Cremorne Gardens.

To us the gross abuse merely signifies that Ruskin could not distinguish between black paint and darkness. But to Whistler it was, with the lawsuit which resulted, the culminating humiliation.

These events produced in Whistler the reaction likely under such circumstances to occur in any man of pride, ability, and courage. He became more and more determined to make his own position unequivocal by an adequate defence. And like a more redoubtable strategist in another field of warfare, he decided that the best form of defence is attack. And so Mr. Whistler's *Ten O'Clock* came to be written. Curious audiences had learned to expect at any rate entertainment from the lecturer. They received their full measure of entertainment, and something else. The oration delivered in London on February the 20th, in the year 1885, at Cambridge on March the 24th, and at Oxford on April the 30th, aroused the liveliest discussion in

various artistic and literary circles. But its full force was not felt until its publication three years later. The interest with which it was received was more than justified. For in the small compass of nine-and-twenty elegantly printed pages was set forth the most concise, uncompromising, convincing and exquisite confession of faith ever made by a painter, in the English tongue. In it the antithesis and cadence of the Old Testament harmonise curiously with an almost Flaubertian economy and polish to form a style strongly personal, the admirably adapted vehicle of nice taste and wounding wit.

But since those days men have come to suspect that elegant style is not the chosen vehicle of wisdom, nor the garments which Truth wears, remarkable. Our own generation, whose vision of the graphic arts is yet preoccupied with abstract design, begins to view the art of writing prose as " nothing but a noble and expressive language ", and is interested once more by Truth herself rather than the manner of her presentation. Nay more : to us, even in works of fiction, some roughness of finish, some negligence in phrasing, is an assurance that the author is almost exclusively concerned with that which he is attempting to express. The eager and hurrying quality of Wells's prose, the heavy groping of Theodore Dreiser's, puts us at our ease, and prepares us to receive with sympathy all that they seek to convey.

The stylistic writers of our period have gone further. In their work disregard of finish has become conscious disregard for grammar and construction. To such

lengths has this fashion prevailed that books are published from time to time which are linguistically hardly more intelligible to the average reader than would be an original edition of Lady Murasaki's novel. But even the boldest experiments of such innovators as James Joyce and Gertrude Stein (who from time to time go so far as to render language itself, as such, meaningless) arouse less suspicion in our hearts than Pater's with its lovely and lucid purity, or Wilde's with its melody.

The *Ten O'Clock* is far too elegant not to be subject to suspicion. But the modern suspicion of the elegant and the supremely competent will pass away with the abundance of empty facility which prompted it, and then the whistlerian statement of faith will be seen without prejudice for the remarkable document which it is.

The aim of the *Ten O'Clock* is nothing less than to demonstrate art's complete independence of all other human activities, and her servant the artist's independence of other men. Art is shown as an isolated phenomenon, having none but the most fortuitous connection with conditions of time or place (" Listen ! there never was an artistic period. There never was an Art-loving nation.") Not only is art shown to be dissociated entirely from special epochs and peoples, but from Nature herself. By a circumstance of peculiar irony Courbet, for whose work Whistler had the profoundest admiration, defined most clearly the attitude towards Nature which is so uncompromisingly attacked

in the lecture. Courbet held that "true imagination in art means being able to find the most complete expression of an existing thing, but never to suppose or create the object. The beautiful exists only in Nature, and the moment it is real and visible, it brings its own artistic expression; the artist has not the right to amplify that expression."

The realist faith was thus opposed by Whistler in several passages which are masterpieces of lucid brevity and wit:

> Nature contains the elements, in colour and form, of all pictures, as the keyboard contains the notes of all music.
>
> But the artist is born to pick, and choose, and group with science, these elements, that the result may be beautiful—as the musician gathers his notes, and forms his chords, until he bring forth from chaos glorious harmony.
>
> To say to the painter, that Nature is to be taken as she is, is to say to the player that he may sit on the piano.
>
> That Nature is always right, is an assertion, artistically, as untrue as it is one whose truth is universally taken for granted. Nature is very rarely right, to such an extent even, that it might almost be said that Nature is usually wrong: that is to say, the condition of things that shall bring about the perfection of harmony worthy of a picture is rare, and not common at all.

If Whistler is at pains to emphasise ideal art's independence of time, place, and even Nature herself, he is even more eager to assert its independence of all but æsthetic emotion. And so it is not remarkable that his bitterest strictures should be reserved for the contemporary critics of whose influence he wrote "while

PLATE II

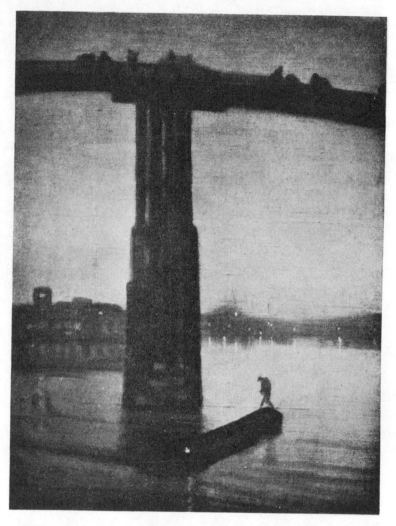

BATTERSEA BRIDGE

*J. McN. Whistler*

*By courtesy of the National Gallery, Millbank*

[ *face p. 100*

it has widened the gulf between the people and the painter, has brought about the moﬅ complete misunder-ﬅanding as to the aim of the picture."

Its aim, Whiﬅler never tired of asserting, is entirely æﬅhetic. Art, being concerned entirely with itself and being an end in itself, has no wish to improve the human race, " for whom," he bitterly complains, " there is no perfeᬏ work that shall not be explained by some benefit conferred upon themselves ". Now the particular benefit which it was at that time thought proper that art should confer was inspiration. The funᬏion of art, it seemed, was to inspire in the human breaﬅ not a love of beauty for its own sake, but such sentiments as patriotism, love, pity, and courage. At a time when such a belief found general acceptance it is hardly surprising that art should have degenerated into nothing more important than a medium for the illuﬅration of lofty sentiments.

It was the passionately desired end of Whiﬅler's writing and conduᬏ to secure the divorce of art from the whole world in general and from all but æﬅhetic emotion in particular. The phenomenal nature of his success has aroused wonder in minds unobservant of the direᬏion of that haphazard movement which men flatter themselves by calling progress. Such minds are sensible of nothing which does not lie upon the surface. They marvel that an unpopular little American, whose ex-travagant foppishness had made him ludicrous in addition, was able, in the face of what appeared to be ineradicable

and widespread prejudice, despite the bitter opposition of the most influential critics, and the example of the most powerful artists, to revolutionise completely the accepted canons of painting. For he accomplished no less. He was greatly talented as a painter, compelling as no other artistic personality of his generation, unsurpassed for mordant wit of word and pen, and possessed of courage far beyond the average. Yet these qualities had little to do with the triumph of his cause, save in that they inevitably marked out Whistler as its champion. A man of supreme personality and genius can effect little of himself, unless the times demand his gifts. But the times can always command talent at any rate to forward the causes most subtly attuned to them. Thus they err who see in the outcome of the struggle between Whistler and his opponents a second triumph of David over Goliath.

True that on the other side were ranged formidable forces. Artists and critics, public and academies, were dauntlessly challenged by the fierce little Impressionist, whom Oscar Wilde described as " A miniature Mephistopheles mocking the majority " ; but Whistler had an ally who was, although unseen, more powerful than critics or artist, than public or Academy.

Whistler limited the scope of the struggle to a single point : the æsthetic issue. Whether the art of the period was, as a whole, in tune with the rest of the age has already been discussed. Unlike Whistler, we claim that art may be relevantly considered from several aspects

besides the æsthetic. Personally I agree with his opponents that there are other issues, but in his views upon that one upon which he chose to fight it is evident that he was making an unanswerable appeal for justice. The universal Church, the monarchy and the aristocracy, as serious art patrons, no longer existed. The new captains of industry and commerce and the democracy had alike chosen without hesitation to patronise the bad artist. Therefore the claims of the good artist to paint exclusively for himself, to possess unfettered independence of all those aspects of contemporary civilisation with which he was so little in harmony, to neglect especially a subject matter which held a meaning only for a public which had decisively rejected his work—all were supported by a degree of logic and justice more than sufficient to uphold them.

The artist's own primary interest is always predominantly æsthetic. A patron of insight, or a sensible patron who is fortunate enough to live in a period when political, social, and economic conditions encourage harmony between the artist and the rest of the community, may harness this æsthetic passion for his own purposes. But a public which these conditions have placed at variance with the artist, and which consequently derides when it does not neglect his work, can hardly expect him to sacrifice his own æsthetic inclinations in order to make comprehensible to it what is to him a mere irrelevance.

Thus Whistler's cause was supported by justice, the logic of which remained hidden from the multitude.

But it prevailed, as an observer of insight could have predicted.

What, then, was the nature, and of what kind the fruits of his victory?

In a word, that process upon which modern civilisation primarily depends had been carried one step further. The principle of division of labour had been extended to the functions of the artist. From now on it was understood that artists were of two kinds. There were the servants of the public, whose function it was to supply the entirely legitimate and comprehensible demands of the public for an art which they can understand, for an art of which the aim is the realistic representation of things which at once stimulate and express its joy, its pity, its sensuality, its sense of romance. There were also those others, who, isolated from the main current of creative activity, were engaged upon the expression of their own personalities, of their own moods and fancies. Among them have been found the most important artists. Indeed, except for those rare cases where the public has for some specific reason commanded the services of a man of real ability, it may be said without exaggeration that the second class has included every artist of genius who has appeared since the industrial revolution.

Like most other revolutions of the kind, the one led by Whistler merely obtained recognition for a change which had already taken place. The division of artists into two classes was implicit in the industrial revolution,

and existed long before the eighteen-eighties. But the change which Whistler actually brought about was this : before his day, for an artist to paint pictures which were incomprehensible to the public was for that artist to insult the public ; to do so since has been to indulge a more or less private and personal eccentricity. If a member of the great public visits an exhibition of what he terms " highbrow " paintings and dislikes it (which he will surely do if he is honest), he regards it no longer as a malicious and gratuitous slight to his intelligence. The breach is complete : this " highbrow " art is something obscure, ludicrous, perhaps clever (by someone else's standards) and infinitely remote.

While the effect of Whistler's teaching upon the artist who served the public was negligible, it exerted a strong influence upon those who were content to paint for themselves or for the few. Among them subject now became more and more an object of suspicion ; until in our own time any work which appeals to any emotions except the purely æsthetic appreciation of design, handling, and colour, is likely to receive something less than sympathy at the hands of the more influential, while even simpler folk are inclined to wonder what the artist is " up to " who presents his subject in too easily comprehensible a form. Progress is continually being frustrated thus : a man comes speaking new truths. His contemporaries first persecute him, more often than is generally realised, with complete success. If he manages to survive and fortune otherwise favours him,

these same contemporaries adopt different methods to nullify the truths which he speaks. Suddenly, inftead of a revolutionary firebrand, they treat him as an oracle. Not as an ordinary, everyday oracle, but as a venerable and conservative oracle whose only fault lies in the timidity and the moderation of its utterances. Nor is it long before new truths have become new farces—so little underftanding does God see fit to grant to moft disciples. Thus are the efforts of genius brought to nothing.

The Whigs of 1688 formulated an enlightened set of principles, designed to prevent the tyranny of kings. The Tories opposed these principles until conditions had so greatly changed that they could themselves adopt them with safety and put them into practice—as inftruments of the moft odious tyranny of class. The tenets of the glorious Revolution, during the reign of William III, were the moft advanced practicable. Then the Tories sullenly opposed them. By the age of the younger Pitt these same tenets had not only come to be closely identified with tyranny and corruption, but by then were the leaft liberal practicable. Now the Tories, attracted by the great preftige which " revolutionary " principles had acquired under the rule of the Whigs, and seeing that they advocated not progress but reaction, changed their attitude, and the praises of 1688 were seldom from their lips.

The average revolutionary outlook is frequently the outcome of an inability to make the fulleft use of exifting

opportunities. But there is about the principle actuating the average conservative mind—and a majority of minds are of this nature—something a degree less inspiring. This principle is, it seems—when a new idea is born, persecute it. Only when it is too old to be of any possible use, adopt it and overwhelm it with flattery. Should comment be made upon your change of front, reply that now the idea has been tried with fire and has yet persisted, it must be worthy of honour.

When Whistler attempted to purge the art of painting of its gross surfeit of subject, every voice was raised in clamorous opposition, showing thereby the general unwillingness to accept the gift which he offered. He was forced, therefore, to raise his voice to a shriller key, to barb yet more poisonously the darts with which he afflicted his enemies, and more important still, to over-emphasise, to affirm with arrogance which alienated, every tenet of his faith—the whole of which became too purely polemical from the start. And when the tide turned and they made him an oracle, it was these very exaggerations which were most admired. The wise sayings of the prophet of a purer æstheticism were neglected, but his angry gestures, savage repartee, grotesque overstatements—all these became objects of adulation.

The doctrines which Whistler formulated were a necessity if painting was to become something more than the slave of anecdote, and therefore they were of the greatest value. But judged by standards other than those of expediency, they are to be found gravely at

fault. Something besides the opposition which, Blake
says, makes the wise man mad, contributed towards the
flimsiness of the whistlerian system. This was a weakness
so deeply engrained in Whistler that it became, after his
passion for painting, the dominating motive of his
nature. There has not been in recent times an artist
whose preoccupation with himself has reached such
intensity, or one in whose life pride has played so great
a part. A nature which combined such self-conscious-
ness with such pride, illuminated by the limelight which
he sought as much as he despised, exacerbated by the
odium which he provoked yet resented, was little capable
of impersonal judgment. Regarding the depth of his
sincerity as an artist there can be no doubt. But as a
writer it is impossible to escape the conclusion that his
aim was the justification of himself and his work.

George Moore has shown in his *Modern Painters* his
awareness of this motive. Of Whistler's theories he says :
" We do not stop to enquire if such answers contain one
grain of truth ; we know they do not—we stop to con-
sider them because we know that the criticism of a
creative artist never amounts to more than an ingenious
defence of his own work—an ingenious exaltation of a
weakness (a weakness which perhaps none suspects but
himself) into a conspicuous merit."

It is a pity that this author did little more than perceive
the motive. A detailed analysis of the relation of
Whistler's theories to his practice from such a pen would
have made fascinating reading.

# Whistler

In Whistler's assertion that "There never was an artistic period. There never was an Art-loving nation" —it is not difficult to detect the protest of one who belongs to no particular nation and lived in an inartistic period. What is important is to examine his main tenet—that art should be independent of all but æsthetic emotion—with his own work. The feebleness of it has been revealed with inexorable justice by McColl:

> This may mean one of two things; either that a painter should never choose a subject with which emotion is inseparably connected, but only pattern arrangements of form and harmonies of colour: or that if he chooses such a subject he must make it not part of his business to express and drive home its emotion; that is to say, in a comic subject there should be no connection between the drawing and the joke, in a tragic, no connection between the drawing and the tragedy. If the first of these things is meant, we shall evidently have to rule out artists like Rembrandt, if the second we shall have to pronounce him a dealer in clap-trap (Whistler's term for emotions other than æsthetic), because, having taken in hand a scene in which devotion, pity, and other emotions are implicated, he has been so artless as to use all his resources of drawing and tone to reinforce them. In the print of the *Crucifixion* the black and white would give some pleasure to the sense as a pattern in black and white only; but the pattern becomes ingeniously beautiful only when the black and white are seen to be significant, to be lights and shadows of things and persons; and it becomes sublimely beautiful, sublime to the spirit as well as beautiful to the sense when the shadows are seen to be the shadows of tragedy. (*Nineteenth Century* article).

The reasonableness of this reply might well give cause



to wonder how it was that Whistler came to maintain with such intensity a position so precarious, and one which implies not only a condemnation of much of Rembrandt's work but also of all but the most hieratic religious art. Important events are seldom, if ever, attributable to a single cause. But the formation of Whistler's doctrine was principally due, after his peculiar sensitiveness to new ideas, to a certain technical incompetence. He possessed neither the powerful draughtmanship nor the sweeping yet definite vision necessary for the accomplishment of the large subject pictures which were the fashion in England. His gifts were more adapted to the French than to the English School. And so in Paris he had little need to justify himself ; and there little was heard of ideas peculiarly Whistlerian.

But once settled in England, his position was entirely altered. His taste was too exquisite and too genuine to permit him to do what the generality of English artists did : to undertake to paint pictures which they had not the ability to carry through. There was not one among them who possessed the power to complete, in the real sense of the word, the kind of subject which all were attempting. And one could as well imagine Whistler tackling and failing to succeed in such tasks as Leighton and Tadema vainly set themselves, as graciously admitting, when Ruskin accused him of cockney impudence and wilful imposture, that he was indeed guilty of such faults. His pride always prevented him from admitting his limitations, but he was sufficiently aware of them to

write a most brilliant artistic confession of faith with the sole object of elevating them into conspicuous virtues. Knowing something of Whistler's character, one may ask whether he could have shown this awareness by clearer means. In his flashing arrogant writing is concealed the admission to God of a weakness which he was too proud to make to man. It was these limitations which made the master ; and there have seldom been greater masters with smaller technical talents.

Ill founded as it is seen to be, it was his doctrine touching the irrelevance of all but æsthetic emotion that exercised more influence than any other of his beliefs or activities. The unequivocal assertion that the end of art lay in itself, that it must be followed for its own sake alone, made him the first lawgiver to the artists of the 'nineties. Powerful as was the influence of France upon him, he had also something of the spirit of Rossetti and of Rossetti's artistic ancestors. He became imbued with all this during the years when the two artists were on friendly, if not intimate, terms. From Rossetti Whistler took his vision of the serene and dreamy-eyed women, and much more besides. And Rossetti saw a resemblance between Whistler's predecessors and his own. " Both he (Courbet) and Delacroix," he writes from Paris in 1864, " are geniuses much akin in style to David Scott, an exhibition of whose works would, I think, make a great sensation here."

Whistler's courage and pugnacity and wit singled him out as the instrument by which the inevitable destruction

of Ruskinian criticism and neo-classic anecdotalism was encompassed. The ability and supreme taste he showed in putting into practice the theories he had inherited made him, chronology apart, the first artist of the 'nineties.

That so large a part of this note should be devoted to Whistler's theories and their results is not only owing to their importance, but to the fact that relatively little has been written about them. Whereas from the biographical standpoint the artist has been abundantly dealt with—so abundantly, indeed, that there is real danger that the memory of one of the most fascinating personalities of his time may be obliterated by Pennell's dreary and misleading *Life*. The poverty of this work is, curiously enough, largely attributable to the same cause as the flimsiness of Whistler's æsthetic canon ; namely, his overweening, his devouring egoism. This egoism, united to a high sense of perfection, led him to attempt to make of his life a pageant for his contemporaries. To this end he took infinite pains with every detail of it. When he wrote for publication, he saw to it that not only was phraseology as elegant as possible but that even the type should be so meticulously disposed as to be in itself a decoration. When he engaged in private correspondence, whether it happened to be with a royal personage or a bootmaker, with his friends or his enemies, his style was equally nice, his calligraphy equally studied. His attention to dress became famous—and hardly less so the care which he bestowed upon the beautification of his house.

But the employment to which, apart from painting, he gave the greatest measure of his energies and his talents, was quarrelling. The seeking of causes for offence, the vigorous prosecution of the hostilities which inevitably followed, the justification *coram populo* of the victor (if it happened, as it generally did, to be himself) in the columns of some newspaper or in some assembly, these were the activities most congenial to him. His natural malice, audacity, persistence, and the possession of a wit which could cut like a whip, suited him admirably for engaging in every kind of feud. And it cannot be said of him that he ever allowed these qualities to fall into disuse. Many of his bitter sallies have become no less famous than his nocturnes. What, for example, could be better of their kind than this provocation and this counterstroke which killed the witty rejoinder it called forth?

"What," asked Whistler, " has Oscar in common with Art? Except that he dines at our tables and picks from our platters the plums for the pudding he peddles in the provinces. Oscar—the amiable, irresponsible, eminent Oscar—with no more sense of a picture than of the fit of a coat, has the courage of the opinions . . . of others ! "

To which Wilde replied :

" Alas, this is very sad ! With our James vulgarity begins at home and should be allowed to remain there."

But Whistler retorted :

" ' A poor thing,' Oscar !—' but ', for once, I suppose, ' your own '."

No less good was the observation, which he made after resigning the presidency of the Royal Society of British Artists, that " the ' Artists ' have come out and the ' British ' remain."

But that this pageant of wit and elegance and sprightliness should merely exist to incense and delight the contemporary world was not enough. Whistler's egoism demanded something more. Not to impress his enemies and friends alone had he undertaken these labours ; if the monstrous appetite were to be satisfied posterity also must be made aware of his genius and his manifold perfection. For dealing with both present and future, Whistler found in Joseph Pennell a useful instrument. Pennell was an example of a type from whose ranks the companions of the declining years of a man of genius are not infrequently drawn. Genius in its years of struggle or in its prime has little use for such companions. But when public applause has robbed its judgment of its fineness, and its coarsened senses demand only the most fulsome and continued flattery ; when it begins from the weakness born of increasing years to need the adulation and exclusive companionship which its peers find difficult to provide, then has dawned the day of the sycophant.

But such was Whistler's nature and such his aims that he needed Pennell's services before either applause or old age had had their effect. For the establishment and maintenance of the primacy in his own *milieu* for which he fought, he adopted a practice to which monarchs

had long been addicted. This practice was a division of function between the ruler and his officers by which the more glorious and more agreeable duties fell to the lot of the former, while the less dignified were performed by the latter. The judge condemns, but the king pardons. His spy is caught and humiliated, but the king retains his innocence. And so by similar methods was Whistler's magnificent façade preserved. Thus was the master able to obtain the fullest effect from his terrific onslaughts, rapier in hand, upon the enemy, from his audacious gestures, avowals, denials; since the ground could, if necessary, be prepared, feelers put forth, enquiries made, by his henchman. Had the master himself been forced to stoop to enquire, to hint and to sue on his own behalf, the effect of subsequent publicly displayed pride and arrogance would have been mitigated: with someone else to perform these offices, the effect was superb.

But Whistler wished yet more of Pennell. So great was his egoism that he considered that the most devoted of his disciples would make his best biographer. It has been asserted that Pennell's book was directly inspired by Whistler. No denial could be more convincing evidence to the contrary, than a comparison between it and any work by the master. It is unthinkable that the author of <em>The Gentle Art of Making Enemies</em>, a volume, for all its malice and pettiness, at once strong and delicate and sparkling, could have inspired directly a volume so wearisome as is this biography. But what

is no less obvious is that one of the most powerful personalities of his day, who knew precisely the character in which he wished to appear before posterity, was able to impose this character with ease upon a disciple so adoring yet so poorly gifted in judgment. Pennell's *Life of Whistler* is nothing less than an attempt, ineptly executed, to impose upon the world a portrait of the master as he wished himself to be seen. The eagerness with which Pennell has taken his subject at his subject's own estimation, and more, constitutes a fault compared with which all its other weaknesses seem trivial.

Their handling of the following incident furnishes a clear example of Pennell's methods. Swinburne wrote an unfavourable critique on Whistler's works[1] which attracted widespread attention, to which Whistler replied[2] with vulgarity and bitterness. So pronounced, in fact, was the virulence of their idol's retort that even our author felt that some comment was necessary. " It cannot be denied," he says, " that he (Whistler) had every reason for seeing a challenge in Swinburne's article." Characteristically, he omits to mention the fact upon which the episode depends, since it shows clearly that while Whistler had every right to reply with reason (as he did in a letter to the poet) his offensive note in *The World* was unpardonable.

The fact was that Whistler had himself begged Theodore Watts-Dunton to use his influence with Swinburne,

[1] *The Fortnightly Review*, June, 1888.
[2] *The World*, June 3, 1888.

whose close friend and constant companion he was, to get him to write upon his painting. Watts-Dunton did as he was asked, and Swinburne paid Whistler the compliment of writing a serious criticism of his work. The true facts concerning the incident have been related in Max Beerbohm's *Number 2, The Pines,* and in Frank Harris' *Contemporary Portraits.* A similar account was given me by William Rothenstein, who like Max Beerbohm had it direct from Watts-Dunton himself.

A *Life of Whistler,* written by such an author, under such conditions, however voluminous and detailed, could hardly do otherwise than obscure the real nature of the man and artist. Whistler is placed upon a pedestal and acclaimed the greatest artist of the modern world. The being whose every act engaged the wrapt attention of his contemporaries does not emerge ; but from the conversation of his surviving friends, from the perusal of his writings, it seems that such a one did indeed exist.

"No one," rightly says George Moore of Whistler, "ever saw Nature so artistically." His vision was of an unrivalled loveliness and swiftness. He looked at some scene, and lo ! the picture of it existed complete in his mind. His own vision he has attempted to justify in his writings. "The work of the master . . . is finished from its beginning."

So sure was Whistler of the perfection of his own vision, that he was unable to draw, as do the majority of artists, fresh inspiration from the work itself. His was the vision of the supreme improviser. If he could not

give almost instant effect to that which he envisaged so beautifully, he found it difficult to do so at all. Nor was this inability solely due to the natural difficulty inherent in a method which does nothing less than substitute a *tour de force* for a sustained search after perfection. To abide as rigidly as did Whistler by his first impression and to pursue it with the same consistency and rapidity, is to forego the powerful aid which is received by the masters when they yield themselves, as it were blindly, to their inspiration. When they do that something which is neither in their subject, nor, as far as they can feel, in themselves, precipitates itself upon their canvases. Of that element which is so baffling to define, yet so immediately recognisable in the greatest art, Whistler's method never allowed him to avail himself. He never yielded himself up but stood outside all this detached, relying only upon his fierce concentration and lovely perception.

He had, besides the difficulties imposed by such a method, to contend with yet another, to which allusion has already here been made. Whistler was not, in the academic sense, a good draughtsman. The genius which he possessed for making the most of all his talents, prompted him to escape the necessity for clear draughtsmanship in the nebulous technique which he developed, perhaps only partly consciously, for that purpose. Whistler was, it seems, an idle apprentice in his young days with Gleyre, with whom he first studied in Paris, nor did he afterwards display any very marked aptitude for

drawing. Although his overweening pride would never allow him to admit his deficiencies, it is certain that he was aware of them. Indeed, it would have been curious if one so shrewd as he had not been.

There are two reasons for believing that he was. Firstly, there is the eagerness which he invariably displayed to be present when his pictures were being seen by those whose good opinion he valued. It was as though, being aware of some deficiency in what he had done, he would invest it with the glamour of his personality. Secondly, there is the exception to the rule of never admitting any deficiency in himself. In a letter to Henri Fantin-Latour he expressed regret that he had not availed himself of the opportunity of becoming a more proficient artist according to academic standards. This is an admission of the deepest significance. For it enables so much in his life, in his painting and in his writing to be rightly seen as an effort directed against this weakness ; sometimes it is an effort to elevate it into a merit, at others to conceal it, again at others to distract the onlooker's attention from it. This consciousness of a certain weakness was ever at war with a colossal vanity. The reaction of the one upon the other appears to me not only to be the key to the deepest recesses of his nature, but to account for its prevailing mood.

His pride was of an extraordinary intensity. It was his desire that his name should be constantly on the lips of all men, that he should stand in relation to his friends as an absolute monarch to his subjects. If he quarrelled

with anyone, he expected, nay, furiously demanded, that all his friends should, with vigour but without question, fly to arms on his behalf.

The wish always to play the central part at any gathering led him to monopolise the conversation. In his drawling American accent, which he preserved as a mark of individuality, he wandered on with apparent aimlessness. Then suddenly he would strike, uttering one of those flashing cruel *mots* which became so celebrated. The preliminary wandering was merely an artifice to achieve a twofold aim : to prevent anyone else from deflecting the conversation into other channels and to manœuvre it into a situation in which he could strike with the deadliest effect. The same desire led him, despite not infrequent acts of kindness and nobility, into an attitude of cruelty. The supreme genius, secure in the knowledge of his power, is likely to be less jealous than a man of the type of Whistler, who in the hidden recesses of his being was aware of his own shortcomings and of the qualities of others. And the consciousness of these things made him cruel in his passion to stand alone, to justify his overweening pretentions before the world. His character may be truly viewed as the outcome of a conflict between the knowledge of his true worth and a vanity which prompted him to pose as a superman.

Fantin-Latour related to William Rothenstein, from whom I heard it, a story which evoked Whistler's image for me with startling vividness.

"There was a time," said Fantin-Latour, "when Whistler and I saw each other constantly. Then we drifted apart for many years. One day he walked into my studio, greeting me with a casual ' Bonjour, Fantin.' He appeared to be looking for my *Hommage à Delacroix*, for when he saw it he called to someone who had been waiting outside, ' Come in, it's here.' A lady entered. ' Me voilà ! ' he exclaimed, pointing to the portrait of himself which was included in my picture. Together they examined the portrait for a few moments. Then they left, he merely saying cheerfully to me, ' Au revoir, Fantin.' "

## Chapter Four

### *Greaves*

WALTER GREAVES is almost forgotten; and when he is remembered at all it is as a ghost of Whistler, as a shadowy counterpart of Enoch Soames. Yet in truth Greaves was not only one of the most important artists of the period, but one whose painting and personality contrasted more sharply with Whistler's than did those of any of his contemporaries. Nor is the validity of this assertion in any way affected because many critics have found the task of distinguishing certain of Whistler's paintings and etchings from those of Greaves altogether beyond their capabilities. And indeed it would be idle to deny that the influence of the master upon the pupil was a very powerful one, or that, as a consequence, there was at certain times considerable resemblance between the work of the two artists. But the similarities were accidental, while the differences were essential.

Between their characters there was no similarity. Whistler was a haughty, polished, cosmopolitan man of

the world, deeply versed in æsthetic theory, sensitive to every new idea, who ended by himself formulating an artistic canon which he defended with the courage of a lion and the ferocity of a wild cat. Sensitive also to each ebb and flow of public opinion, he cared for the admiration not only of his contemporaries but of all posterity ; and to obtain it he became jealous, a *poseur*, and although usually vicariously, something of an intriguer. In spite of the price which he was willing to pay for the gratification of his pride he remained always a powerful and a dazzling figure.

Greaves is the son of a Thames boat-builder and waterman. He is a man for whom the world, with its controversies, its admirations, its hatreds, has no meaning. His world, which is dead, did not extend beyond the river banks of Old Chelsea and Old Battersea, or his life beyond the feverish activity of the inhabitants of the water-fronts, mostly long quiet in their graves. Aesthetic theories and the new movements which accompanied them would have affected him little, even had he been aware of them.

His own attitude towards his work is fully contained in a reply to a question once put to him. We were talking of his boyhood, and I asked him how early he started to paint. " I never *could* help it," he said, " Chelsea was so beautiful that you couldn't but paint." Such an attitude makes theory superfluous. Pride and jealousy had no place in his character, but all the while he had a consciousness of his own power, a sense of satisfaction

which came from the ability to express his innermost feelings. But transcending all other differences between himself and Whistler was the fact that he was entirely unlike his cosmopolitan master in being intensely national, even local, in his outlook and his technique.

Of the two Whistler had by far the more original vision. He saw in the day and night effects of the Thames a new, hitherto undiscovered and exquisite material for the making of pictures ; his subtle eye was instantly captivated by the designs suggested by the bridges and river banks and arrangements of lights. And so the American gentleman with the fierce glance and foppish garb made his own the changing mood and atmosphere, the mysterious distances of our gas-lit river, with a grace and a tenderness born of the deepest understanding.

Greaves' motive was different. He painted the river simply because he loved it for its own sake. The Thames-soaked and blackened timbers of the bridges, the slow barges with their red sails, the hoarse melancholy cries of the watermen coming through the mist, and above all the illusive mist itself and the grey water which lapped continually at the foot of the house he lived in : these were the things he loved, neither for the design they made, nor for their atmosphere, but for themselves. And Greaves, about whom there was always something childlike and direct, went straight for the qualities which he felt.

The only influence which ever affected him was

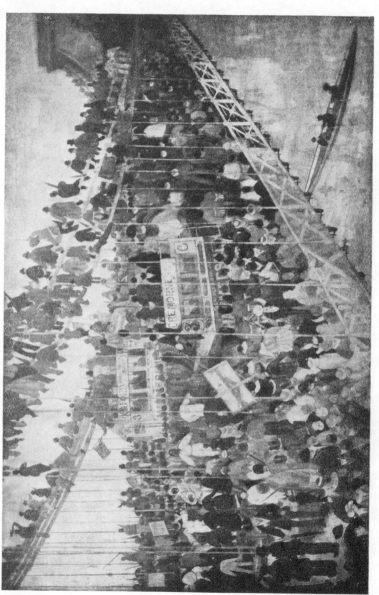

[face p. 124

HAMMERSMITH BRIDGE

*Walter Greaves*

*By courtesy of the National Gallery, Millbank*

# Greaves

Whistler's. For a time the older artist dominated him completely, but the tendency to return to a more native vision became stronger and stronger. When this naïve, intense, native vision was adequately served, Greaves was able to paint pictures which place him among the first English artists of the nineteenth century. The *Hammersmith Bridge* alone is sufficient testimony to his power.

Since so little material relating to Greaves' life exists, and since his own account of it, somewhat disjointed as it was, brought something of the life of the Chelsea now no more, and of his own youth, so vividly before me, I feel that I cannot do better than attempt to reproduce it as closely as I am able. The brief account of his life which follows is based upon notes taken down by me during conversation with him.

"I was born (he said) during the late 'forties in Lindsey Houses, now Cheyne Walk, Chelsea. My father was Charles William Greaves, a boat-builder and boatman. My brother Harry and I drew and painted as soon as we could walk. We started by painting crests on boats and armorial bearings, and then encouraged by my father we went on to river scenes. My father didn't either draw or paint himself, but he was friendly with several artists. The one whom he knew best was Turner, who lived only a little way away from us, in Cremorne Road, I think. Although he knew Turner well, he never knew the man he was, that is, not until afterwards. My father said that Turner was fond of sketching in

125

Battersea, and used to send his landlady, Mrs. Booth, across the river before him with his luncheon. When he did that he would always accompany her as far as Lindsey Houses to ask my father what the weather was going to be like, and if he received an unfavourable reply he would say to her, ' Don't go far. Greaves says it's going to be wet.' My father rowed Turner several times on the water, who always, he said, was dressed the same way, in a dirty faded brown overcoat and top hat.

" Then there was another artist who lived near us, only about four doors away. He was John Martin, you know, the one who painted *The Day of Judgment.* Whenever there was a storm and my father had to stay up all night to look after the boats, Martin used to say to him, ' If there are good clouds and a good moon, ring my bell.' And when there were, he would ring the bell, and in a little while Martin would come out onto the balcony of his house and start working.

" Except for those two, and afterwards Whistler, Rossetti, your grandfather John Knewstub, my brother Harry and myself, I never heard of other artists living in Chelsea in the old days. In those days it was all so different and so gay. It all seemed so lively, with people going to Cremorne dressed in bright-coloured clothes, with the fireworks and the regattas. There were two clubs, the Ranelagh and the Wellington, and their yachts used to start at old Battersea Bridge and race to Wandsworth three times up and down for a silver cup. Then there was the Female Blondin, as the girl was

called, who walked five times across a rope ſtretched across the river. All sorts of things have changed now. I remember the old fire engine, that was kept in a ſtable in Church Street. The man who looked after it slept above, and when there was a fire they used to wake him and he would put his head out of the window and yell 'What's up?' And when they told him there was a fire he threw down the key and went to sleep again. Then they unlocked the door beneath and brought out the engine, which ten men worked, five on each side. And how the carters used to fight in the part of the cobbled ſtreet juſt near our house, where it narrowed! Sometimes the barges would sink, and I saw whole families who lived in them ſtruggling in the water, and watermen fishing them out with boathooks.

"Then one day we were painting on the river bank near our place, when Whiſtler, whom we knew by sight as a neighbour in Lindsey Houses, came up to us and watched us at work. He said suddenly, 'Come over to my place,' and we went there and he showed us his work and his Japanese things. I loſt my head over Whiſtler when I firſt met him and saw his painting. Before that my brother and I had painted grey, and filled our piĉtures with numerous details. But Whiſtler taught us the use of blue and made us leave out detail. At firſt I could only try to copy him, but later I felt a longing for my own ſtyle, and something more my own did come back.

"We often used to ſtay up all night on the river

with him, rowing him about. When he came to a view which interefted him he would suddenly ftop talking and sketch it with white chalk on brown paper, juft showing the position of the lights and the river banks and bridges. Juft as suddenly he'd ftart laughing and talking again. The next day I'd go round to his ftudio and he'd have it all on the canvas. He got me into the way of working like that.

" For many years we saw him nearly every day. We attended to all the work of his ftudio, mixing his colours, ftretching his canvases, preparing the grey diftemper ground he used to work on, and painting the mackerel-back pattern on the frames. We muft have done all this for close on twenty years. Besides this we helped to paint the inside of his place in Lindsey Houses. When he gave dances we used to play the piano, but he only liked one tune, and he couldn't dance—not really. Of course, we never got so much as a shilling for all that we did, but we never minded that.

" I very well remember Whiftler's mother coming to ftay there. When he went away I used to go and ftay at his house in order to look after her. She was a religious woman, a bit too religious, I thought sometimes, but she was a perfect lady and very fond of me, too. I often used to see Carlyle—everyone about there did—but I never got to know him even when I painted his portrait. He seemed a gruff man, and hardly answered when you spoke to him.

" As I said before, I went mad over Whiftler. I can

see him now, with his scowl and his top-hat over his
eyes. He used to dress peculiarly—long yellow frock-
coat. A regular Southerner he was : West Point, wasn't
he ? He always used to say so. People ran him down, I
know, but he was a very nice fellow, and very hospitable,
too ; but he wanted knowing. He considered himself
the greatest artist of all—that was Whistler. Then one
day he got married, and vanished.[1] I know Pennell[2] said
that Whistler worked on my etching of *Lime Wharf*—
why, Whistler never even saw it. He said he could
detect Whistler's work in my *Battersea Bridge*, but
Whistler never saw that, either. I never could make
out Pennell's reasons for going on as he did. I had never
done him any harm, and he came along to me when he
was writing Whistler's *Life* to ask for what I knew.
But don't let's talk about Pennell.

"I still draw. In fact, I couldn't pass the time

[1] Whistler's own account of the break in his association with the Greaveses has been related by Sickert, with characteristic spirit. "History," writes Sickert, "was this : Whistler had an exhibition somewhere (don't ask me for dates or places), and after it was over he asked the Greaveses if they had seen it, and they said, ' No '. Act of *lèse-papillon*, and no mistake, here ! They made it worse by saying, ' they didn't mean any-thing by not going.' Worse and worse ! ' If you *had meant* anything. . . . ' Words failed ! You can see the scene from here. Whistler added that some time after, a common friend had been to see them and that they had said that ' they were painting pictures on the method of Whistler up to Academy pitch.' " (L'Affaire Greaves, by Walter Sickert : *The New Age*, June 15, 1911.)

[2] When Greaves held an exhibition at the Goupil Gallery in 1911, Pennell, incensed by what he chose to see as disparaging comparisons between Greaves and Whistler, seized upon an unintentional inaccuracy in the artist's foreword to the catalogue as a pretext not only for making the most virulent attacks upon Greaves' painting and attempting to discredit the old man's memory, but for throwing doubts upon the authenticity of some of the works in the exhibition. Without proper knowledge of the matter he asserted in numerous newspapers on the one hand that " already . . . much of Greaves' work has been foisted on the public as Whistler's," and on the other that various etchings supposed to be by Greaves were really by Whistler.

without it. I think I could draw all old Chelsea by heart. I don't suppose I'd get it extraordinarily exact, but I can *see* the place all right as I do it.

" I never seemed to have any ideas about painting—the river just *made* me do it. You see, you have to have them if you paint in a studio; but if you are outside all day, as I was, by the river, all you've got to do is to watch the red-sailed barges passing. And then there was the bridge—I suppose Battersea Bridge got a bit on the brains of all of us."

Such is the account he gave me of himself. And when we last parted, and I saw him—a small, grey, lonely figure in the sunlight, waving me good-bye from his door in the Charterhouse—I became poignantly aware of his situation. Nor was it possible for me to remain unmoved in the contemplation of this aged man, one of the great artists of his time, sitting alone and forgotten in his little room, sketching old Chelsea from memory because he " couldn't pass the time without it." And the man who first hid his light under a bushel was his jealous god, Whistler.

# Chapter Five

## *Steer*

WHILE his obscurity is in no way comparable with the obscurity of Greaves, Philip Wilson Steer is relatively unknown. The ardent admiration of a few discerning critics and collectors, his work has evoked almost from the first, and his name commands respect even where his work is little known.

But he would work with the same love and persistence even though no human eye were ever likely to see the results. To the admiration of the world he is indifferent. The appreciation of his devoted friends means a great deal to him; but even this is not essential. He would work on even without that. Perhaps he is concerned with the opinion of posterity. But I think that if he knew for certain that the Day of Judgment were due on this day week he would continue to paint and to draw with the same serenity as though nothing untoward were imminent.

Steer paints, in one word, purely for the love of painting. His indifference to the opinion of the world being inherent in him, it is only to be expected that he has never withdrawn himself from the world, in the manner

131

of the man whose indifference is not inherent but assumed, with a completeness in any way provocative of mystery. To become a known " recluse ", a mysterious person, Steer would not only consider in bad taste (and what is, in truth, more ostentatious in a man of talent than a too strictly preserved seclusion?) but something even worse. Such unnatural seclusion would inevitably have the effect of concentrating upon him a degree of public attention which would embarrass him. Therefore he has never withheld himself from his friends, save at times consecrated to painting, he has exhibited along with his fellows and even done a measure of teaching.

This consideration touches what I believe to be the essential motive of his nature. Steer is a man with a great passion and a great talent for painting. And his whole being seems to me to be organised with the sole end of gratifying this passion. Other artists whose passion for their art has been no less intense than Steer's, have hoped to obtain something by it beyond the satisfaction of practising it. A born artist works so instinctively that the immediate end he has in view seems to matter little. Whatever the motive which sets him to work may be, once he is started he almost inevitably brings to bear his abnormal powers of concentration, industry, and imagination, intense conscientiousness, and in addition an artistic morality. An artist may work, or for lack of immediate motive may not, and merely remain an artist *in posse*. But once working, from whatever cause, he tends to work for the sake of

his work alone, and to become subject to an artistic morality governed by purely æsthetic laws. Directly he ceases, he may without prejudice to his art devote his entire attention to the immediate aim.

Balzac, Walter Scott, and Tolstoy were all great artists ; and the fact that Balzac wrote largely because he needed money and loved it, or Scott to save his beloved Abbotsford, or Tolstoy to reform mankind, probably made little difference to their writing. Their immediate desires made the first two write more than they would otherwise have done, and if his affected Tolstoy's later work it was because his moral motive was nearer to art than was the desire for money. So near was it, that it sometimes tended to blunt somewhat his æsthetic sensibility. In fact, the clearer the separation between the accidental and the purely æsthetic motives in an artist, the less likely is his work to be adversely affected.

Many artists, devoted as they are to their own arts, hope to obtain through them fame and wealth and love. An author, whose delicacy and perception and wit are rarely paralleled in contemporary fiction, told me without affectation of his strongest stimulus to artistic creation. " I write chiefly," he said, " so that I shall be famous, and I only want to be famous so that I can get to know more and more women. After the publication of my next book I shall meet a good many more, I suppose."

Now Steer does not make use of his art to acquire fame or riches or women. Nor does he practise art for

abstract love of it. But he paints simply and solely because he loves painting. Instinctively (for Steer is a creature of instinct rather than reason, but of instinct immeasurably sure) he protects himself against everything which might threaten his painting. Instinctively, therefore, he is careful to avoid too much fame, to avoid equally publicity in the newspapers, and seclusion which would be likely to create a mystery, bringing publicity with inevitable waste of time and unnecessary responsibility. He never plumbs ideas deeply or maintains with fervour this or that theory. (" I never had many theories about painting, and I don't know that I have now : all that one has to go on are nature and tradition," he said to me.) For theories dissipate the energy which should be devoted to painting alone ; label one as a member of this or that school of thought ; involve an obligation to uphold its doctrines on all occasions ; create irrelevant hostilities. All abstract ideas and the disputations which they breed, which have for their aim the elucidation of the truths which underlie the practice of all art, appear to Steer merely as irrelevant distractions from practice. Nor would it ever occur to him to pose as a man whose gifts are so great that he can dispense with the controls of the intellect. And so he listens to the talk of his learned friends, McColl, Moore, Tonks, and Harrison. He listens and plays his part in the conversation, even if at times he becomes listless and even sleepy.

Of more concrete threats to the gratification of his

passion for painting he is no less wary. George Moore, in two wholly admirable pen-portraits of his friend, tells us of the care which he takes to avoid them. In the dedicatory epistle to Steer in *Reminiscences of the Impressionist Painters*, he writes: " Haven't we often laughed at you, saying that you walk in the middle of the street at night lest a tile should come on your head or break at your feet and put you off work the next morning: a man must keep cool if his model is coming at ten." The same author in the more mature portrait in *Conversations in Ebury Street*, observes that " . . . Steer dreads getting wet even as his cat, and he dreads draughts; draughts prevail even in sheltered nooks and draughts are like wild beasts, always on the watch for whom they may devour."

Moderation and diffidence, conventionality and caution are the means which Steer, guided by an unerring instinct, uses to protect himself from the world. And these means are not so rarely used by men of genius as is generally supposed. That Newton should have avowed himself before everything else a Whig and a churchman, and affected more interest in his work at the Mint than in scientific investigation has puzzled many. To me it appears that Newton's mind was a mechanism perfectly adapted to thinking, so sensitive in its nature that it shrank automatically behind a mask of conventionality in order to avoid all contacts likely to disturb its delicate balance. And it seems reasonable to suppose that a similar instinct has guided Steer,

# Steer

In the garden of Steer's life, thus walled by his instinct, has flowered an art of miraculous completeness. Greatly, although by no means supremely gifted by the gods, Steer has, by infinite concentration, a profound understanding of the nature of his gifts, achieved a body of work more uniformly perfect than that of any of his contemporaries. In his landscapes the traditional English manner of Richard Wilson, Constable, and Turner is blended harmoniously with all that the Impressionists have contributed to the art of painting. His vision ever since he left Paris has become more and more English and traditional, but his debt to Manet and to Monet is always evident. As a landscape painter (and it is to landscape painting more than any other kind of work that he has devoted his life), his most remarkable power is that of envisaging a great expanse of country, and setting it down upon the canvas with strength and understanding. And as a painter of flesh he is certainly without a living rival in England and probably in Europe. The chief faults of his early work, later completely mastered, were a certain diffuseness, an absence of form clearly defined, and of underlying construction. But these belong to a past now almost remote.

For many years Steer has painted both landscapes and figure pieces with a sureness of construction, a purity of vision and a supreme distinction of finish which gives them a quality possessed by no other contemporary paintings. There is in them nothing hard nor sharp,

neither tragedy nor comedy. These landscapes and interiors are painted exquisitely yet robustly, without comment yet with infinite love.

As might be expected, Steer's life has not been eventful. But as nothing, to my knowledge, has been written about it, I will give a few of the principal facts relating to the earlier and obscurer part of it.

The son of Philip Steer, an artist, and his wife, who had been a Miss Harrison of Chester, he was born at Birkenhead in 1860. When he was three years old his family moved to Apsley House, Whitchurch, Monmouth, where he lived for seventeen years, attending in the meanwhile Hereford Cathedral School. As far as his recollection serves him he first started to draw and to paint at about the age of sixteen, when he went to the School of Art at Gloucester, to which city the Steer family presently moved. The art master under whom he studied was John Kemp, who gave him far more intelligent instruction than he would have received at the average provincial school at that time.

Bitterly disappointed by his failure to pass into the Royal Academy Schools, he went in the early 'eighties to Paris. Here he studied first at Julien's under Bouguereau. His bitterness was quickly turned into the most lively sense of relief when he heard his English fellow students discuss their experiences at the Royal Academy Schools. The move that he made after a brief sojourn at Julien's to the Ecole des Beaux Arts he owed to the kind offices of Cabanel.

I once asked him whether he profited greatly by the teaching he received in Paris. " Bouguereau," he said, " used to come round and speak to me in French, of which I didn't underſtand a word, and spend his time correcting, say, an eye when the whole figure was wrong. Sometimes other ſtudents used to translate what he said, but that hardly made it easier. Cabanel was very different. To begin with, he looked very different. Bouguereau looked like an old shopkeeper, while Cabanel was a Second Empire swell; he wore always a top hat, frock coat, grey suède gloves, and ſtays, I think. He used to come and sit beside one, and without saying very much he would draw in with one line, in the charcoal which we used, a whole side of the figure which one had completed, juſt to show how it should have been done. And he did it beautifully. If he wished to rub out anything he did it with one of his suède gloves.

" Although it was very academic Cabanel's ſtudio was free, while next door in Gérôme's, where I often wandered, the ſtudents were engaged in turning out Gérômes. At Julien's, where I painted, I might have learnt more if I'd underſtood French; at the Beaux Arts I was only allowed to draw."

It has several times been asserted that the Manet Memorial Exhibition of 1883 exercised a powerful influence upon Steer's work. That may well have been the case. Nevertheless, I was intereſted to hear his own account of his views of that Exhibition.

" When the Manet exhibition was held I had never

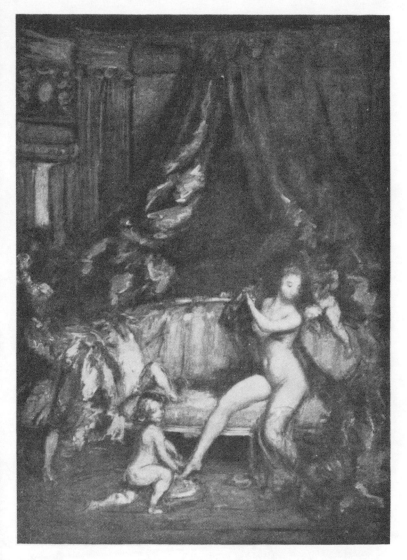

THE TOILET OF VENUS

*P. Wilson Steer*

*By courtesy of the National Gallery. Millbank, and Mr. Frank Green*

[ *face p. 138*

heard his name. But I went, and was very much interested. The nudes struck me as being blown-out looking things. The landscapes I liked very much better, especially one which I think was called *Blue Posts, Venice*."

In 1885 he returned to England and settled permanently in London. Much as he had learned from the French Impressionists he was not yet entirely free of his early illusions about the Royal Academy. There he sent several paintings which he had done in Paris, and one, a study of an Italian girl's head, was immediately sold. But as his work grew in power the Academy became less friendly.

Meanwhile he underwent a new experience. At the opening exhibition at the Grosvenor Gallery he saw for the first time some works by Whistler. They interested him deeply, although he thought that " they seemed too misty, the figures appeared as though they were in a fog. But there was something very good about them."

When the New English Art Club was founded by a group to whom Impressionism had given a new inspiration, a group in hot revolt against the vapid pseudo-classicism of Burlington House, Steer was among its first members. He has ever since been one of its most consistent adherents.

The later part of Steer's life has been, from the biographical point of view, uneventful. He has painted steadily. From June until the middle of October he does landscapes in the country. The rest of the year he is in London, engaged upon his nudes, interiors, and

landscapes composed from water-colour ſtudies made in the country, and occasionally, a portrait. These laſt are less important than his other work, for Steer is without the psychological insight necessary for the rendering of a complete portrait. But considered simply as paintings of models, they have the beauty which is inherent in everything he does. He has travelled abroad hardly at all, although he made some time ago an expedition to Holland to see the piƈtures there.

" We all ſtrive towards oneness, but only Steer has attained it," says George Moore. There is truly about Steer, about his art and about his nature, a unity which is deeply satisfying. The very mention of his name brings to my mind a vision of his drawing-room at 109 Cheyne Walk. Beside the fire a tall ſtout man, on rather a small chair, sits with his ankles closer together than his knees, smoking conſtantly. His voice is quiet and even. In his judgments, spoken in a simple, almoſt commonplace way, one recognises rare wisdom. The room is full of excellent furniture, pieces of china, enamel, bronze, which all have a reticence which would render their discovery unlikely by anyone who had not the moſt subtle discernment. Againſt the walls lean the paintings of the large gentle man. They are completely in harmony with the eighteenth century furniture, the pieces of china, enamel, and bronze. But the man in the chair does not know that one is aware of this harmony and this fitness ; for he says : " I have a ſtudio upſtairs, but I always prefer to work here."

## Chapter Six

### *Sickert*

SINCE Whistler first sounded the onslaught upon literary subject in painting, the attack has developed so powerfully that the enemy is now outside the gates. It has developed with hardly less consistency than force. Literary subject now counts for nothing : form for everything. The movement has gone so far as to render subject not only meaningless but actually obnoxious, something at best gravely suspect by the more fashionable members of the artistic public. A picture depicting a " situation " is taboo—unless it happens to be a Sickert.

That this should be so is due in part to the inherent weakness of the doctrine that art must be for ever precluded from dealing with emotion ; in part to the peculiar nature of Sickert's character and position. Clearly none of Sickert's pictures is literary in the sense that it is of the kind which the spectator cannot understand unless he happens to be acquainted with a certain line of poetry or some anecdote or other. But in the sense that they often depend for some part of their effect upon other than æsthetic emotions, they must be classed as literary.

141

# Sickert

Let us for a moment consider the artist's well-known *Ennui,* which hangs in the Tate Gallery. Low tones, sombre even lighting, forms in themselves melancholy, contribute greatly to the almost intolerable sense of ennui with which the picture inspires the spectator : but that the main effect is the result, not of ennui abstractly expressed in colour and line, but in terms of human pose and expression, is indisputable. So charged is the picture with emotional interest that it is this quality which first strikes and then holds the spectator.

Literary as a great number of his pictures are, and ostensibly hated and despised above all others as that quality is by the leaders of contemporary criticism, Sickert is hailed on all hands as a master. The Academicians have elected him an Associate of their august society, the advance guard of the younger critics praise him in their exclusive journals. Yet he has neither the finished technique dear even to the reformed Academy, nor has he adopted the abstract presentation of his most " advanced " juniors.

At the first glance such general acclamation appears both illogical and mysterious. Closer examination, if it will never reveal logic, at any rate clears up the mystery. In the chapter here devoted to Whistler is quoted a paragraph from McColl's *Nineteenth Century Art,* which disposes, as completely as a brief paragraph can dispose of an elaborate and intelligently supported theory, of the error that art should have no relation with any but æsthetic emotion. That theory was the result of a

swing of the pendulum from one extreme to the other. During the nineteenth century subject had loomed larger and larger, until in Whistler's day all æsthetic considerations had become subordinated, to an extent intolerable to an artist of pride and sensibility, to a subject-matter which had itself become trivial and degraded. The theory of "art for art's sake" was an historical necessity to restore the balance which great art demands between æsthetic considerations and subject.

It is a curious illustration of the slowness with which group thought proceeds, that the self-styled leaders of the most "advanced" school still "believe in" a doctrine for which there is now about as much justification as there is for the theory of the divine right of Kings, and one which has long ago been shown to be as radically unsound. Fortunately the faith of these self-styled leaders in the doctrines which they profess is not so implicit as they would have us believe.

To show how far, in the case of these critics, faith is removed from practice, or rather, profession from actual belief, we need only show them a picture by Sickert, and place pen and paper in their hands. They will reveal themselves devotees of the old religion of subject and emotion and sentiment, after all. Thus to reveal themselves they need do no more than praise to the heights a picture which owes three parts of its effect to emotions which differ radically from æsthetic appreciation. In uttering this praise they are doing more wisely than they

know. For there is, if little enough in their doctrine, a rough unconscious logic in their taste.

When such words as " situation " and " emotion " are mentioned in' connection with a work of art, the mind of the hearer is, naturally enough, likely to hark back with suspicion and disgust to the middle and later nineteenth century, the heyday of subject. During that time subject not only assumed grotesque proportions, but became in itself vulgar and degraded. Subject, and the kind of subject most jarring to present-day susceptibilities, became the mistress, and technique, reduced to abject servitude, declined as do all things which are ruthlessly exploited for too long. In technique are included composition, tone, quality, and draughtsmanship ; and these things, no longer valued for their own sakes, were fast vanishing.

To the subject characteristic of that period that of Sickert bears not the slightest resemblance. Instead of trite and sickly felicities, sentimentalities remote and empty, and moralisings without relevance to life, Sickert shows us a world which is drab, dirty, disillusioned, a world whose pleasures are mirthless and whose devil is boredom. A world, in fact, such as we know. Our whole world is not so dreary as Sickert's *Camden Town*, its tones are not so low, nor its women quite as ugly. Yet he presents an aspect of life which is immediately convincing, convincing beyond argument. In their recognition of Sickert and his presentation of his view of life, the modern critics show that they do not in reality

despise subject, but on the contrary, when they find subject which expresses their own feelings, they hail it with delight. Only, as most modern art critics are poorly equipped for their task, they cannot discern the merit of the work of artists who present another and equally real aspect of life, an aspect genuinely romantic, tender, or positive. They can see only black and white—vulgar sentimentalities on the one hand, and cynicism, disillusionment and sordidness on the other.

Sickert has understood and painted "low life" as none of his contemporaries has done. In a faintly smiling, impersonal manner he has depicted the pleasures and the sorrows of the people. With insight he has shown us their garish amusements and their dreary homes ; music halls and sorry interiors. It is characteristic of our epoch that to the democracy which Sickert understands so well, his own pictures are incomprehensible. To a working man a picture by Sickert would mean less than one by any other realist. For the democracy is in a ferment. It can only slightly and incoherently express its desires for change. And so it is not interested in itself as it is, but as it thinks it is going to be. But even if that were not so a working man would rather see a painting of the inside of the Gaiety Theatre than the Bedford Music Hall—any day.

The charm of the gilt and glitter in the café and music hall, the wit of vulgarity, was felt and expressed by Sickert earlier and more keenly than by any English artist of his time.

# Sickert

Sickert has claims to fame beyond his power of presenting emotions to which his age instinctively responds. Many English artists have studied in Paris and been deeply influenced by the great French masters of the last century. But none of them has absorbed so much from France and yet remained an English painter. For although there is about Sickert's pictures something of the cosmopolitan element which distinguished Whistler's, there yet remains in everything he paints an element of humour definitely English.

And so in the public mind he holds the position of the chief link in the chain which binds the young English painters of to-day to the great traditions of nineteenth century France. By nature Sickert is admirably suited to sustain such a position. A wit, trained in the school of Degas and Whistler, a lucid and amusing writer, the doer of the erratic and the unexpected, his is a personality which always holds the attention of everyone who comes into contact with him. As a young man he was a dandy, but he was careful lest his good looks should be rendered commonplace, as good looks often are, by dandyism. And so from month to month he varied the manner of his elegance, introducing always into his dress some incongruity which would keep the commonplace perpetually at bay. A friend told me how he once met Sickert in Whistler's house in the Rue du Bac in Paris about 1892 arrayed in a faultless black and white check suit with peg-top trousers—and a large and heavy pair of boots.

# Sickert

Sickert's real master was Degas, not Whistler. For a time he was under Whistler's influence, and from him he acquired the low tonality which he has always retained. But the influence of Degas was both the stronger and the more permanent. Indeed, there is little of Sickert's work which does not bear some trace of the influence of this master. The outstanding characteristics of Degas' work were strong and scientific draughtsmanship, and a realism often bitter and satiric. His method was synthetic, in that he built up his paintings with the aid of a multitude of sketches and his exceptionally retentive memory. From the middle 'eighties Sickert, on the advice of Degas himself, adopted this practice and worked thenceforward from drawings rather than Nature. His master's scientific attitude towards his painting he has also emulated. Like him, Sickert has felt that instinct is not a guide sufficiently sure, and has always employed his keen enquiring mind in constant exploration of new methods, and always adhered consistently to the method of the moment.

The actual manner in which he early applied paint to canvas he has retained, little modified by the passage of years. He builds up his painting, like a mosaic, by the application of innumerable patches of pigment. But in his manner of doing it he varies the practice of the main body of the impressionists. They applied touches of various colours which when juxtaposed gave the effect of the final colour which they intended : Sickert applies touches of his final colour directly.

## Sickert

Sickert has a vision which is neither so large, nor so deep, nor so intense as his master's. In technical accomplishment also he falls short of him. But he is an artist who possesses great qualities. His insight into his subject is keen and subtle. Subtle and delicate, too, are his tones. Only rarely are vitality and wit absent from his pictures. And last of all, his is an honesty too rarely found. Aware of technical imperfections on his own part, he will, in planning a picture, often evade certain difficulties with great ingenuity. But every difficulty which he determines to face, he attacks with a courage and probity which are true measures of his quality.

# Chapter Seven

## *Conder*

GREAVES is more fortunate than Conder; for he is almost forgotten, but Conder is faintly remembered and lightly despised. Even those whom Beardsley's work moves least, are willing to grant him certain powers of imagination, and originality of vision, which they deny to Conder.

Yet Conder was one of the most considerable imaginative artists that England has produced, and one of the most beautiful colourists.

Charles Edward Conder was born in London in 1868, the son of James Conder, a civil engineer and a descendant of the sculptor, Louis François Roubiliac. Very shortly after his birth the family moved to India. At the age of five he returned to England, where he was sent to school. In 1885, in spite of having expressed a wish to devote his life to painting, he was sent to Sydney, Australia, to join an uncle who held a post under the Lands Department of New South Wales.

The following year, wearied by the life of a surveyor, he obtained a poorly paid post as illustrator on the *Illustrated Sydney News*. Presently he left Sydney, and

the year 1888 found him in Melbourne engaged in an attempt to live by painting.  Here he drew a little from the life, but the greater part of his energies was devoted to the painting of landscape.  His meeting at Melbourne with Arthur Streeton, an artist of some ability, resulted in a quickening of his æsthetic consciousness.

Although his work at this time was generally feeble and unformed, the Australian environment had one lasting effect upon him.  From it he learned his love of fruit blossom, which he was never to tire of expressing. Beyond this, Australia seems to have affected him little, and I cannot agree with the opinion of his friend, Jacques Emile Blanche, who says that it was characteristic of Conder to be lost in a day-dream ". . . sans doute quelqu'un de ces sites indiens ou australiens, *coloniaux* en tous cas, qui étaient le décor habituel de ses hallucinations."[1]  When Conder day-dreamed (and he day-dreamed often), it was neither of Australia nor of the Indies, but of orchards and wooded hills and green fields in Normandy, or small French villages that he loved : Vetheuil, La Roche-Guyon, Chantemesle.

For confirmation of this opinion I can call no surer witnesses than his imaginative landscapes.  In these there is no hint of India or Australia.  All are formed on Northern France or Southern England.

In Melbourne he exhibited at least twice, and one of his pictures attracted so much attention that an uncle offered to defray a part of the expense of sending him to

[1] *Essais et Portraits.*

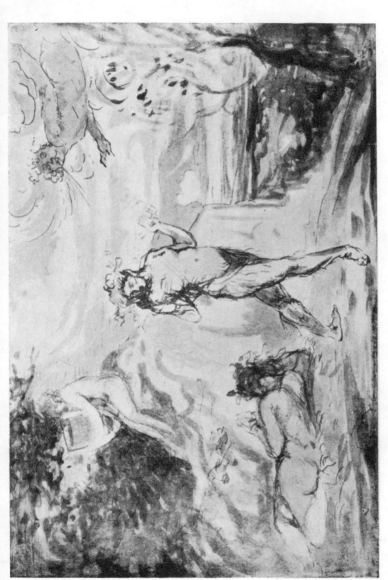

ALLEGORICAL STUDY

*Charles Conder*

*By courtesy of Professor William Rothenstein*

[face p. 150

Europe to study art. And so in the summer of 1890 he returned to England, and in the autumn of that year went to Paris, where he entered Julien's. Here he met William Rothenstein, and the two became lifelong friends. Rothenstein was struck rather by the personality of the large blond student than the quality of his work. His painting was then anæmic, self-consciously æsthetic, sugary, and sentimental. His drawing was even more feeble. Directly he came to Paris his work began to develop rapidly, and a certain awkwardness of demeanour to fall from him. He was gifted with a capacity unusual in an Englishman for understanding the Gallic outlook. French he soon learned to speak with speed but never with accuracy.

Although to the end of his life Conder was never able to work regularly, his scheme of work in the early 'nineties was roughly as follows. Night after night he went to the Moulin Rouge and other places of the same kind, and watched enthralled the crowds who, animated by that curiously fierce Parisian gaiety, bustled confusedly in the gaslight and the smoke, and the exotic evolutions of La Goulue, Nini-Pattenaire, and Jeanne la Folle as they danced the Can-Can. Sometimes he made a rapid sketch but more often he simply watched, trusting in his extraordinary powers of memory. So retentive was it, that even when he had a stretch of country, or a still-life, or a sitter before him, he found it necessary to look up but rarely from his work. In the morning he would set down what he had seen the night before, transformed

and enriched by his imagination. Thus he would continue all winter.

But the firſt signs of spring inevitably drew him from the smoke and confusion of the cabarets away to the banks of the Seine, to the orchards of Normandy, where he could paint his apple blossom. Then as spring ripened into summer he went yet further north to the Normandy coaſt, to Yport, Dieppe, and Pourville. Here he entered the society of which Blanche and Sickert are the beſt-remembered figures. Directly the mellowness of autumn was chilled by the firſt touch of approaching winter, the Parisian cabarets saw him once more.

Because he gazed so enraptured and intent upon the Parisian scene, it muſt not be supposed that he was always an onlooker. An artiſt of superb appearance and winning manners, if fired only with the cool flame of ambition, and gifted with a Caledonian caution, may remain an undiſturbed spectator. But neither cold nor cautious was Conder, either at this or at any time.

He was tall, very blond, with his hair—which was heavy and soft—parted in the middle ; his soft blue eyes looked out somewhat absently—equally soft and vague was his voice. There was about his conversation the same unfinished quality that characterised his painting and his writing, which gave to all three something infinitely rich and suggeſtive. A nervous habit of dragging one foot ever so slightly when he walked, a barely perceptible awkwardness of movement and manner, gave to his whole being an element of illusiveness, of in-

tangibility. The effect of such good looks, so subtly qualified by these very slight defects, was a magnetism which men felt and women found difficulty in resisting.

Of women he had a deep and immediate understanding. His attitude to life was careless and rabelaisian. Such a man, however great his appetite for work, cannot remain a spectator for long. So all through his life, and especially during these Parisian days, there were long periods when work counted for nothing. For weeks together he used to disappear ; but directly the blue bird had flown out of the window he would rush back to Paris raging with fierce desire for work. In this mood he was capable of prodigious feats of endurance. For when the desire was upon him he worked almost oblivious of the passage of the days. Then gradually the pace would slacken and the eye once more begin to rove.

There was much else besides the practice of painting and dissipation to occupy Conder. He and Rothenstein, with whom he lived for the greater part of the year 1890 at 13 Rue Ravignan, high up on Montmartre, were among the few English art students who at this time associated intimately with their French *confrères*. One of those whom they saw most often during 1890 was Toulouse-Lautrec. For him Conder had the greatest admiration, and he in return was affectionately amused by Conder. Lautrec had a great sense of character, and to him Conder, with his enormous stock and other signs of original foppery, seemed the very type of the English eccentric.

# Conder

In spite of his friendship with Lautrec and Bonnard, his admiration for Degas and Puvis de Chavannes, and intelligent interest in contemporary French painting, his own æsthetic outlook at first did not greatly change. The prevailing mood of the Paris of that time was too much removed from his own for it to affect him fundamentally. When he met Louis Anquetin all this was changed.

Conder was a pure romantic, bred in England and Australia. Anquetin was a romantic also, but a romantic whose environment had been of a very different kind. He had started in the opposite camp, as an ardent banner-bearer of the Independents, whom he finally abandoned, and gave free rein to the natural romanticism of his nature. And so when he came to know Conder he was able to interpret French painting to him and reveal its richly romantic qualities. This curious balzacian figure, who looked like Michelangelo and rode about the countryside mounted upon a great charger, was the most potent influence in Conder's life. For Anquetin's magnificent if somewhat preposterous exterior concealed a mind of exceptional force. Conder never lost the admiration with which Anquetin inspired him for the work of artists so diverse as Rubens, Goya, Watteau, Fragonard, Daumier, and Constantine Guys.

The influence of these and of Anquetin himself began to affect Conder's work, and it now rapidly acquired the qualities which were to remain characteristic of it. Once he had discovered a manner and a subject which suited

him, his work changed little.  From that time until the
end of his life his composition became steadily bolder
and more intricate, his colour stronger and subtler ;  but
in essentials it developed along lines which were already
clearly marked as early as 1893.  In that year he painted
the first of those fans in which his art may be seen
most perfectly exemplified.  Mrs. Jack Gardner, who
was shown one of them by Rothenstein in the autumn of
the same year, was the first collector to recognise their
beauty.  Considering how obvious, at least to the
English eye, seems the debt which these fans owe to
France in general and to the eighteenth century in
particular, it is interesting to read the opposite opinion
which Blanche expressed in a tribute to them.

" Ses éventails sont presque tous des chefs-d'œuvre.
A quoi pourrais-je les comparer ?  Nullement aux
éventails français du dix-huitième siècle.  Le style de
Conder est purement anglais."[1]

Blanche is a critic of judgment and experience ;  he
was a warm friend of Conder's ;  he is the author of the
most authoritative pen-portrait of him that has yet been
written.  And as the opinion of one so well qualified to
speak, I have quoted it.  I can think of but one explana-
tion for an assertion seemingly so perverse.  If anyone
lives in the midst of his own nation, society or family
which has an especial characteristic, however strange that
characteristic may be, he will not be particularly aware
of it, since it is the common denominator of the entire

[1] *Essais et Portraits.*

group. In the same way, it seems, Blanche, who is an erudite scholar of his own country's art, is unaware of one characteristic of it which a foreigner can perceive at a glance, although he might not easily be able to define what he saw. The quality which has eluded this distinguished critic is the peculiarly *national* flavour of the art of his countrymen. That there is something of this flavour about the fans of Conder must also be obvious to any foreigner. What of course, on the same hypothesis, must be freely conceded, is that an Englishman is incapable of appreciating to the full the purely English qualities of Conder's art.

By 1893 the first phase of his painting was closed. He no longer saw the world as a place in which the song of the nightingale filled the air and the fading rose covered the ground with its tender petals. This mirage was a logical consequence of his Australian environment and his immersion in the Rubaiyat of Omar Khayyám. If Blanche has shown himself unable to perceive certain qualities in Conder's painting, he has tabulated with felicity the images which henceforward crowded his mind :

Les personnages de la Comédie Italienne, de Molière et de Balzac, tous un peu confondus dans le kaleidoscope de son cerveau, un mélange de l'époque de Louis XV et de 1830 ; un joli bric-à-brac de chaises à porteur, de berlines, de cabinets de laque Vénitien rococo ; des gondoles, des portiques de treillages, des rideaux de quinze-seize contorsionnés " par Zéphir " ; tels sont des modèles et des accessoires qui reviennent

# Conder

sans cesse dans l'œuvre de Conder, où le chapeau de Rastignac s'aplatit presque en tricorne, où la souquenille du valet poudré a presque des mêmes pans rheingrave de la Restauration. Postillons au fouet claquant, facchini, soubrettes, jeunes seigneurs courtisant une almée à la Coypel, nègres au turban empenné, fifres et tambours, vous êtes tous les invités au bal d'Esther, dans la Chaussée-d'Antin, et vous êtes les favoris de Charles Conder.[1]

With this new imaginative phase came much admiration and a measure of financial success. The Société Nationale des Beaux-Arts elected him an associate member in 1893, and he exhibited there regularly. Although from this time his success was assured, he had not lacked encouragement since his first exhibition. That he held jointly with Rothenstein in 1891, at Thomas' Gallery in the Boulevard Malesherbe, when the work of both artists was favourably received by the Press and reproduced in *L'Art Français.*

From 1894 he made London his headquarters, although he continued to paint in France and exhibit in Paris from time to time. In 1901 he married Miss Stella Bedford, and took 91 Cheyne Walk, where he settled permanently. Henceforward his life became less eventful, and his output greater. Ill health made him feel that he had not many more years of work left. And the realisation of it gave him a feverish intensity which he had never known before. He would sit over a meal with friends and talk, to all appearance, with his accustomed indolence and light-heartedness, and then

[1] *Essais et Portraits.*

157

suddenly he would fall silent. A worried, anxious look transformed his face, and he would go ſtraight away to his ſtudio.

And at no time did his efforts meet with greater success than during those few full years between the beginning of the century and his laſt illness. Never had his extraordinary capacity for organising the moſt complicated and subtle poses without reference to life shown itself so powerfully. I can think of no other English artiſt who could, without a single note, without preparation of any sort, carry out large and intricate designs as Conder did. He was never a good draughtsman, his sense of conſtruction was vague and faulty, yet a terrific feeling for design and atmosphere enabled him to accomplish what he did. Had he been slow of imagination and technique, had he been forced thereby to reflect for long upon what he was about to attempt, it is likely that he would never have attempted it. But as it was, the gods fortunately made him somewhat blind to his own weaknesses.

An idea never inspired him but it gripped him with such force that he could not pause. Working at an amazing pace he set it down, oblivious of all things but his idea. And so, in a kind of raging dream, he was able to accomplish infinitely more than his capacities seemed to warrant. The power of creating a world of his own, and peopling it with the children of his imagination, was Conder's. In many of his fans and panels are combined with singular perfection his imagination and his

# *Conder*

sense of design. Within the small compass of a medallion
he gives us a view, as through a minute window, of the
world of his creation, in all its my$tery and completeness ;
and in the arabesques which surround it he rejoices the
eye with his gentle and wi$tful delicacy.

The medium in which he be$t expressed himself was
water-colour on silk. Careless about the quality and
condition of his oil-paint, brushes and canvas, he took
endless trouble to procure the silk which suited him be$t.
As a painter on this material he has no modern rival.
Indeed, it is difficult to recall fans of any period which
excel the be$t of Conder's, such as *The Key of Blue*,
*Thorn and Mistletoe, Fickle Love*, and *The Yellow Fan*.
Equal to these in gracious beauty are the pairs of panels
formerly in the colle&ion of the late John Quinn.

Besides his paintings on silk and canvas, he made
between 1899 and 1905 thirty-seven lithographs, and four
etchings. The Balzac set, which was his fir$t, he did
upon the urgent persuasion of Rothenstein, who was just
then in the middle of his own mo$t prolific lithographic
period. Conder's faulty draughtsmanship never showed up
so clearly as when he used this medium. And yet no other
arti$t has felt so poignantly nor expressed so exa&ly the
spirit which pervades *The Human Comedy*.

Conder also illu$trated two books, *The Story of Beauty
and the Beast*, and *La Fille aux Yeux d'Or*. In addition,
he designed several suites of rooms for Mrs. Holford
and Sir Edmund Davis. These he carried out himself
in a brilliant but untidy manner.

## Conder

Conder never seems to have written anything for publication. But there is about his letters the same curious, glamorous intimacy, the same confused beauty that animated moſt things which he touched. Between 1890 and his laſt illness he and Rothenſtein corresponded whenever they were separated, and I have before me several hundreds of his letters. I wish I could quote freely from them, for they give a portrait of their writer truer and more finished than anything which I could hope to achieve. But I am prevented, not so much by the rabelaisian nature of many of them, or even the malicious things which he said of several now living who have written claiming him as a friend, as by the sense that these letters give me so ſtrongly of being for the eyes of one person alone. There is in them an intimacy of expression which gives me the sensation of eaves-dropping whenever I read one of them. When a large number may sometime be published together, which will give a fair idea of Conder's nature, which charaĉteriſtic excerpts would only obscure, the case will have altered. For the present one quotation muſt suffice, one quotation which has none of the disadvantages that I mentioned, which yet throws a little light upon the mentality of the writer. This passage occurs in the middle of a long letter written on the 14th of Auguſt, 1895, from 2 Rue de l'Oranger, Dieppe.

> I have rooms opposite the church, an enormous Gothic one, and a piteous saint at the door with geraniums on his head in garland.

# *Conder*

The whole front of the sea is simply magnificent, and reminds me of one's comprehension of some past time in our century— it's lovely to see the famille bourgeoise again, and finer still to see de Merode, the dancer at the Opera and a dozen such. If you can come over from Saturday to Monday it is *worth while*, and I will get you a room. I am sure you will not spend more than ten francs a day unless you want to. Smithers has made Aubrey Beardsley editor of the new publication, I suppose you know that. The first part of the *Fêtes Galantes* is to come out in it. *Amusant, n'est-ce pas?* I might tell all about the place here but the sea air leaves one idle. One likes to believe oneself hand in glove with all sorts of poignant emotions, but the sea is like some drug which makes one satisfied with the desire. Life is so beautiful that one thinks it must end soon, and ambition only comes in and interferes and makes one want to do for example pictures of next spring illustrated with portraits. It is very likely I shall settle here, I like the place so well and fancy that the winter months will be encouragingly dull and good for work. I can't appeal to you now as a reasonable man, I know, but still the idea seems good.

These letters are a continual expression of passionate delight in the beauty of sun-bathed countrysides, blue seas and skies, and above all, of women. The joy in all these is of a quality far more robust and humorous than one would imagine judging from his paintings alone. There runs through his letters also a vein of gentle melancholy. " Life is so beautiful that one thinks it must end soon " is a refrain often repeated. But sentimentality is quite absent from them. For all his romanticism, Conder was deeply preoccupied with the practical side of life. Oscar Wilde perceived his

preoccupation and was a little scornful of it. He said to Rothenſtein : " Conder is wonderful, my dear Will, he takes you aside and persuades you with that irresiſtible acumen which is the peculiarity of poets, to buy a fan for five pounds for which you are perfeɗly prepared to pay twenty."

All through Conder's life his vitality was being undermined. (For vitality, despite superficial indolence, there was in abundance.) He was incapable of abandoning a way of life that was killing him. For a time he was able to do some of his lovelieſt work under the effeɗ of alcohol. But gradually it became more and more evident that alcohol and other excesses were having their moſt terrible results, for his mind became subjeɗ to fits of aberration, his body to continual illness.

I remember once, as a child, hearing the front-door bell, and expeɗing a friend, I hurried into our high dark hall. Inſtead of my friend ſtood a figure of tragedy. Its eyes were ſtill blue and its hair golden. But beneath the gold hair the skin was grey and the rims of the blue eyes were red. Inſtead of entering it lingered, I felt, lonely and ashamed, until my father came out with a greeting.

Two years later, on the 9th of February, 1909, Conder died in the Virginia Water Asylum.

## Chapter Eight

### *Beardsley*

THE promoters of the fabulous legend of the 'nineties have insisted that Aubrey Beardsley was its epitome.

In my studies of Whistler, Greaves, Steer, Sickert, and Conder I have tried to show them as men whose importance derives from their work and personalities, rather than their association with a legendary group. The group described in the legend had no existence during the 'nineties. Looking back upon that age across a space of more than thirty years we are able to perceive that certain strong affinities existed between certain artists. There was a similarity in their unconscious reactions towards the two most significant factors affecting modern art, namely, industrialism and classicism. If, as was the case, the majority of the artists of the 'nineties knew each other, and many of them were bound together by ties of the strongest friendship, it was because there were among them some of the most attractive personalities of the time. Their associations arose out of the natural attraction which vital personalities have for one another.

If Beardsley could not epitomise the spirit of an

exclusive and exotic clique which never had any exist-
ence save in the minds of its inventors, his art was pro-
foundly characteristic of the actual group which we are
able to see so clearly in retrospect. His instinctive
attitude towards industrialism is clearly shown by his
constant attempt to create a world of his own, a
fantastic and exotic refuge from the present. From this
refuge all things significant of the modern world were
excluded.

Hardly less clear is his attitude to classicism. I say
"hardly" because his eclecticism led him to borrow
from classic art as he borrowed from every other, so
slightly obscuring the purely romantic nature of his own
creations. His disregard for the classical canon, his
insistence upon character, his predilection for the
exaggerated and the grotesque, all testify to the absence
of the classic spirit from his nature.

More pronounced than his antipathy for industrialism
and classicism was his hatred of the conventions which
had been built up by the middle classes during the
reign of Victoria. Never was there an age when so
gigantic a gulf had yawned between profession and
reality. A false refinement forbade the mention of
the real nature of man's instincts. His greed, his
lust, and his cruelty were no longer spoken of. And
because these things ceased to be mentioned they ceased
also to be thought of as ever-present realities. Despite
the unspeakable misery in which nine-tenths of the
population lived, despite the corruption which reigned

in social life, " All's well with the world " remained the order of the day. In art and literature good was regarded as the only ultimate reality and evil as nothing more than its foil. Darkness was only tolerated that the glory of light might by contraſt appear the greater.

After more than half a century of unproteſting submission to the dictates of hypocrisy, the society of late victorian England had become more sensitive to moral shock than any which hiſtory records. Its sensitiveness was of a peculiar type. A man might sneakingly commit adultery throughout his life, and yet not greatly offend ; but let him advocate free love and boldly practise it upon so much as one occasion, and he was for ever an outcaſt. For belief and action to tally—that was the great offence. The victorian attitude towards the whole of life was reflected in its attitude towards religion. The attitude has never been more exactly expressed than by the man who described a typical congregation of the period as one which " would be equally horrified at hearing Chriſtianity doubted, or at seeing it practised."

By the final decade of the century the opposition to such an outlook had already taken definite form. But the victorian conspiracy of silence had been attacked neither so remorselessly nor so boldly nor so effectively as by the dying consumptive boy, Aubrey Beardsley. Nature had equipped him perfectly for his task. His was a vision fierce, sensitive, precise. His courage was far

above the ordinary, never more movingly displayed than in his laſt letters to his unnamed friend.[1] He had in addition a passion for great fame which he knew could only be achieved by sensational means, because of the shortness of his days.

His own attack did not open simultaneously with his career as an artiſt, and it waned before his death. His work passed through four clearly marked phases. The second of these alone is dominated by the satirical motive. It would be well to examine these four phases in chronological order.

The greateſt among Aubrey Beardsley's gifts was his power of assimilating every influence and yet retaining, nay, conſtantly developing, his own peculiar individuality. This individuality of his was so clear-cut almoſt from the firſt, his gift so limited if so splendid, that it was impossible for him to subjeƈt himself to the influences, in a profound sense, of the artiſts whose work he ſtudied, and yet remain true to himself. All he could do was to capture fleeting fragments of their vision, their methods, their mannerisms. This he did with consummate skill, never failing to adapt whatever he took to his own uses. He took outward things alone from other artiſts ; the spirit informing every important work he undertook after the *Morte d'Arthur* was unmiſtakably his own, and even in that there is much that is purely Beardsley.

How clearly he himself was aware of his plagiarism is shown by the following extraƈt from one of his letters :

[1] *The Last Letters of Aubrey Beardsley.*

# Beardsley

" To-day I had hoped to pilfer ships and sea shores from Claude, but work is out of the question."[1]

Several critics who have examined and described the various phases through which Beardsley's work passed have assumed that his adoption of each successive phase was due to his subjection to a new influence. The critics to whom I refer are confessed admirers of the artist's work, who, it seems to me, in many respects greatly overpraise it. But in one they wholly fail to recognise its greatness. Whatever his shortcomings as a creative artist, Beardsley was an eclectic of genius. An eclectic of genius is not a man who merely borrows the conventions of other artists ; but one who expresses himself with their aid. In other words, the phases through which Beardsley passed were expressions of his own inner development. He borrowed what he needed at each stage, instead of being dragged hither and thither by one enthusiasm after another, as these critics pretend. The orderly nature of his progress is sufficient in itself to confute any such idea.

His development was of a peculiar kind. It must be remembered that from a very early age he knew that he had not long to live. The significance of this knowledge to anyone who was so greatly in love with life, so avid of experience as he, was that everything must be compressed into the few years which remained. Although there was about his progress an element of self-consciousness, it was never so strong as to make him attempt

[1] *The Last Letters of Aubrey Beardsley.*

to force its pace. What he did was so to ſtimulate his mind, by conſtant contaĉt with his fellow men (he became a considerable social figure), by reading (he always read prodigiously), by hearing music (he was a regular frequenter of concerts), by experiencing much (he experienced in certain direĉtions more than his biographers are inclined to concede), that it should miss no opportunity of completing its evolution.

His firſt phase is admittedly such as to encourage the conclusions to which I have taken exception. No very definite motive beyond the purely decorative appeared in his work. He seemed to have been fired firſt by the Italian Primitives, but finding them too remote, to have taken the easier course of imitating their modern imitators, Burne-Jones, Puvis de Chavannes, Morris and Walter Crane. Derivative as they are from the Pre-Raphaelites, the illuſtrations to Malory's *Morte d'Arthur* —by far the moſt important work of this earlieſt period —are by no means without merit. In them he displayed the power of imagination, sense of design, and technical accomplishment which became so significant in his later work. It was in any case a formidable task to have carried through for anyone as youthful and inexperienced as Beardsley was in 1893 and 1894. For he made designs for twenty full and double pages and no less than five hundred and forty-eight chapter headings and tailpieces. The *Morte d'Arthur* is a fine teſtimony to his courage and his perseverance, but it also shows that he did not express himself naturally on such a scale. Even Beards-

ley's most fervent admirers admit that the effect of such sustained effort was to make the work uneven in quality. But uneven and derivative as it is, the *Morte d'Arthur* places the fact of Beardsley's technical skill beyond doubt. Such accomplishment as his is rare in modern times. The vision, for instance, of Whistler or Sickert was far beyond their technical abilities ; whereas Beardsley was able to put down on paper precisely what he wanted.

His was the skill of the mediæval craftsman. Had he lived in the middle ages instead of our own the demands which would have been made upon his ability might have created an artist of the highest rank. As it was, one immense task was given him, and afterwards so much of his great talent was allowed to go to waste in the expression of trivial morbidities.

Neither of the two artists whose influence upon Beardsley at that time was so marked, realised the nature of his gifts. Burne-Jones recognised his talent and encouraged him with sympathy rather than understanding. Morris saw even less. Aymer Vallance got Beardsley to do a design for a frontispiece for *Sidonia the Sorceress*, and to show it to Morris, who, after remarking bluntly that the face of Sidonia was not half pretty or attractive enough, added : " but I see you have a feeling for draperies." After this episode Beardsley would never see Morris again.

In any case, the events of the next months would have put an abyss between them. During that time Beardsley had ripened suddenly into maturity. The

prevailing influences became the Japanese print and the Greek vase. But the manner in which these influences were received had entirely changed. In the first phase he was allowing himself to be dominated by a spirit and a convention altogether alien to his nature. From many of the drawings done in this period the real spirit of Aubrey Beardsley seems to leer in melancholy defiance of an environment so little suited to it. In the second this spirit had emerged and become dominant. The new manner perfectly expressed it, and all that was pilfered from Japan was strictly subordinated to this end. In the drawings of this second, the *Salome* period, there is no riot of japonaiserie for its own sake, but utilisation of Oriental formulæ to give added intensity to an art which was individual, hard, and eminently Occidental. The union between vision and expression was now complete. But the perfection of execution and bizarre and biting satire (this was his satirical period) seem to me to conceal imperfectly a bitter intellectual yearning, a consciousness of a desire to do something more than satirise.

Meanwhile, his natural high spirits were being worked upon by success, by exaggerated praise and blame. And so, while he satirised the latent evil in the age, he revelled in the evil which he himself depicted. He combined the character of inexorable exposer of the evil which convention hid, with that of its high priest. His work began to take on something of the austere hieratical quality characteristic of religious art. The

# Beardsley

illustrations to Wilde's play, *Salome*, and those published in *The Yellow Book* were the most important products of the second phase.

Towards the end of 1895 a new element entered Beardsley's art. Like the Japanese and the Greek, the conventions of the French eighteenth century were now taken and subordinated to purely beardsleian ends. The significance of this change does not lie in the introduction of elements of French eighteenth century decoration into his design, but in the decline of his satiric mood.

The way of the satirist is to place profession and reality side by side, so that the discrepancy between them may shock the onlooker. Therefore any man who is a satirist must feel such discrepancy keenly. I believe that Beardsley, often as he revelled obviously in the evil which he satirised, was oppressed by it. Hypocrisy was alien to a mind so imperturbably clear. Dissipation, practised with taste and frankness, or austere professions justified by ascetic conduct, he understood. The history of the end of his life is a history of the change in the balance between these two sympathies.

The eighteenth century, with its clear limited objective, its rational outlook and its acknowledgement of human frailty, was able to achieve a greater harmony between profession and practice than those which immediately preceded or followed it. And so, when Beardsley, largely owing to his friendship with Conder, discovered the age of Watteau, Fragonard, Crébillon, and Chesterfield, a certain unhappy tenseness which had

171

before been present in his work now left it. In this third
phase it was as though he were rejoicing in a subject in
which he could believe. Since he believed in it, satire
was no longer necessary : his entire energies were con-
centrated upon beautiful rendering. The illustrations
of *The Rape of the Lock* are as characteristic of this as are
those of *Salome* of the preceding stage. If the later
drawings have a richness and finish which the earlier
ones have not, they are without something of their
bizarre and fascinating atmosphere.

Of the final phase, upon which Beardsley entered so
shortly before his death, it is difficult to speak with
precision. For the time between the last momentous
change and the end was so brief, so fraught with suffering,
that the artist could do little. One fact at least stands
out clearly ; that Beardsley, who had borrowed from
every art to aid his own expression, began to turn towards
Nature herself. Of becoming a naturalistic artist he
showed no sign. His own vision remained as clear and
individual as it had always been, but he clothed it in the
garments of Nature rather than of art. In the *Volpone*
designs Beardsley bent the conventions of nature to serve
his purposes as sternly as he had the conventions of Eisen
and Saint-Aubin before.

This change in his art was only a reflection of the
greater change that had come over his outlook on life.
To make clear the character of this final change it is
necessary to lay some emphasis upon a fact which many
of those who have written upon Beardsley have either

omitted to mention or by implication denied. Neither would it be mentioned here unless I believed it to have had a very real effect upon his development. It has been said that his morbid tendencies were expressed in his art alone. I have the best authority for believing this to be wholly untrue, for asserting that during one short period his life was very dissolute. Further, it is clear that he allowed himself to be persuaded by certain of his friends, to make many drawings which were obscene for obscenity's and not satire's sake. Many of them were sold for large prices to collectors who were interested rather by their pornographic than their æsthetic qualities. It was owing to Smithers's influence that Beardsley continued to do such drawings after the mood had left him. Among these, curiously enough, is the *Lysistrata* series which seems to me to include the finest examples of his art. In this case their rabelaisian nature is more than justified by the text. Beardsley, while he was engaged upon them, wrote to his friend : " My pictures in pale purple are for Aristophanes and not Donnay."[1]

Beardsley's evolution had been towards a deeper seriousness and a greater dignity. Nothing, I believe, did so much to quicken this tendency as his own realisation of the sordidness of much of his conduct. The final change was brought about by bitter remorse at the use which he had made of his life and his gifts. Evil, however gracefully and however frankly practised, was no longer a sufficient end for life or theme for art.

---

[1] *The Last Letters of Aubrey Beardsley.*

So the influence of the eighteenth century, for all its graciousness and candour, ceased to inspire him. In the *Volpone* designs something of its convention remains, but that could hardly have been otherwise, considering how rapid was the transition.

Beardsley's final mood could only be expressed æsthetically in naturalistic, and emotionally in religious, terms. The difference between such terms and any he had used before was very great. In his early design *La Beale Isoud at Joyous Garde* he is at pains to show that several of the branches of the small trees in the foreground do not belong to them, but have been tied on with string. This gives the measure of his former preference for artifice over Nature. Emotionally the change was no less complete : extreme cynicism was supplanted by religious enthusiasm.

Allusions in his letters and other writings show that Beardsley had been sensible, for a considerable time before his conversion, of the attraction of the Catholic Church. The beauty of its ceremonial and its liturgy, the drama and antiquity of its history, appealed alike to the artist and the historian in him. But something more than an admiration for externals was necessary to induce one so cold, clear-sighted, and detached to break completely with his past. Beardsley's sense that he had spent so great a part of his brief existence in the expression of mere morbidity, had allowed himself to be persuaded to prostitute his talent, had spent some time, however short, in vicious living, filled him with a desire

for atonement. That he already loved the externals of the Catholic Church, and one of his closest friends was a member of her priesthood, predisposed him in her favour.

Far more important was the fact that the Church stood in a particular relationship to certain forces which underlay Beardsley's ideas and conduct. I have tried to show that however diversely it manifested itself, the profoundest spirit, which unknown to themselves, animated the men of the 'nineties, was the protest against industrialism. Now it is clear that the Catholic Church, whose concern, before everything else, is the salvation of the individual, must be hostile to certain important conditions of an industrialised society. Complementary to the concern of the Church for the salvation of the individual, is her insistence upon the necessity for individual responsibility. For the individual to have the opportunity of marring or perfecting his own soul postulates immense personal responsibility. Industrial society does not prevent the individual from exercising his responsibility, but it does militate against his doing so. Questions at issue between Church and civil society there must always be, but these inevitably become acute when the nature of any society causes it to hinder the exercise of a function vital to the salvation which is the principal object of the Church. The complexity of the organisation of an industrialised society so narrows the function of the individual that no one man is answerable for more than a minute phase of any activity. The

Press, the cinematograph, the wireless, and mass production standardise his character, his opinions, and his appearance. Since the action of such a society tends to deprive the individual of both the will and the ability to be answerable to himself, and to make of him a mere standardised mechanism, it follows inevitably that it challenges the responsibility of each man to himself, which the Church holds to be the necessary condition of salvation.

There is no evidence, indeed there is little likelihood, that Beardsley's mind worked consciously along these lines. But the drabness and disorder against which he and the other artists of the 'nineties uttered their vehement if largely unconscious protest, was the direct result of the working of the standardising tendencies inherent in modern society. The majority of them sought refuge from it in the practice of their art rather than the practice of religion. Of those who can be termed " of the 'nineties " the proportion who either maintained their Catholicism intact or afterwards entered the Roman Communion is surprisingly large. Francis Thompson and Lionel Johnson both remained devoted to the religion of their birth, while besides Beardsley were converted his friend John Gray, who entered the priesthood, Ernest Dowson, Alice Meynell, the Michael Fields, Lord Alfred Douglas, André Raffalovitch, and Frederick Rolfe, better known as Baron Corvo. Oscar Wilde, as a friend who was with him when he died told me, expressed a wish to be received into the Church, but

became unconscious before his reception could be completed.

The effect of his conversion upon Beardsley was remarkable. From the slightly vulgar and very self-conscious *poseur*, about whom there had been a feverish restlessness, he became kindly and serene—in a word, wholly lovable. Rothenstein, who had shared rooms with him in 1894, and known him well, told me that he had never seen anyone so completely changed as Beardsley when he visited him in Paris a few months before his death.

Despite the surprising nature of his artistic talent Beardsley often asserted—without affectation, his friends thought—that he would rather have been a writer. Certainly his writings have qualities akin to those in his drawings, which give them a unique if modest place in English literature. As a reader his capacity was extraordinary. The way in which, in the course of a few years, he managed, in addition to his vast output of drawings, full social life, and interest in music, to absorb the greater part of English and French literature, from the most learned works to the most trivial, to say nothing of great quantities of the classics, is little short of miraculous. The greatest admiration of his life was for Balzac, whose characters, as Blanche says, "Aubrey les connaissait comme les membres de sa famille."

## Chapter Nine

### *Ricketts and Shannon*

THE work of these two artists differs greatly, but it is
convenient to treat them jointly, since they have been
closely and continuously associated for more than forty
years, and since their work is, in spite of its difference,
the result of environment and influences substantially
the same. It has one important quality in common in
that it embodies the most conservative element in the
painting of the 'nineties, namely, the element of
Classicism which remained in a school essentially
Romantic.

In an earlier part of this essay I have attempted to
show that the painting of the 'nineties represents the
confluence of two streams, that of the English Romantic
tradition deriving from Blake and handed on by Scott
and the Pre-Raphaelites, and that of French Impression-
ism. The definition of a school by its artistic antecedents
is valid only if it is considered in its entirety. It is clearly
not applicable to each individual artist. While in many
of Whistler's paintings the influence of Rossetti is hardly
less evident than that of the Frenchmen, one scans
the canvases of Ricketts and Shannon for traces of

## Ricketts and Shannon

Impressionism no less vainly than one does those of Sickert for evidences of Pre-Raphaelitism. That which unites all three of these artists is that the primary concern of each is æsthetic. This I believe to be true in spite of the very strong pictorial element in Sickert's painting which I have already emphasised; in spite of the fact that Ricketts one day declared to me that he and Shannon were " unashamedly literary ".

I have no logical justification for this belief : I simply feel while looking at the pictures of these artists that they have been moved rather by the intrinsic beauty of certain forms than their relevance to some subject which is either before them or in their minds. Subject is made to conform to æsthetic considerations, while beauty is seldom sacrificed that some theme may have clearer or more forceful expression. This seems to me even truer of Ricketts and Shannon, who confess to being " literary ", than of Sickert, whose associations have mostly been with a system which defers little to subject.

Ricketts and Shannon became associated at the very outset of their lives as artists, having met in 1884 at the art school at Lambeth. Charles Ricketts was born eighteen years earlier in Geneva. His father had been a naval officer who had retired to devote himself to the painting of seascapes. The Ricketts family travelled considerably, so that Charles was able to familiarise himself with several of the Continental art-galleries, most of all with those in Paris.

Charles Hazelwood Shannon was born in 1863 at

179

Sleaford, Lincolnshire, the son of the Reverend F. W.
Shannon, the rector of the village. When he went to
Lambeth he was unsophisticated in artistic matters
compared with the younger boy. Thomas Sturge Moore,
one of their earliest friends, described to me the small
circle which Ricketts and Shannon animated with their
own passionate and exclusive devotion to the arts ; and
the brown papered room in the Kennington Road which
the two artists shared, with its walls covered and its floor
littered with reproductions of the works of old and
modern masters. " Ricketts," he said, " whom I felt to
be the most original person I had ever met, looked in
those days, with his thin colourless face and long light
hair, more like a dandelion puff than anything else.
He was blithe, alert, active, and an extremely fast
walker."

The picture which Moore drew was of a minute
society, poor, austere, unworldly, but exclusive, with no
other interests in life save the appreciation and practice
of the arts. And so from the very start Ricketts and
Shannon were absorbed by art rather than life. While
their *confrères* in London were philandering with pretty
models and making expeditions abroad only ostensibly
to paint landscapes, or sipping drinks upon the Parisian
Boulevards and keeping late hours at the Moulin Rouge,
Ricketts and Shannon, by the study of reproductions in
their attic in Kennington, were laying the foundations
of the great scholarship which was to distinguish them
both.

# Ricketts and Shannon

Both at this time, before they had been mellowed by contact with the world, were, for all their enthusiasm for art, somewhat aloof and pedantic. This I once heard vigorously maintained by Ricketts himself. A young man was asking him about his early life, and Ricketts said : " Hadn't you always heard that in those days we were both pedantic and disagreeable ? " The young man replied a little unconvincingly that he had not. " Yes," continued Ricketts genially, softly striking the table with flattened palm, " I *insist* that we were pedantic and disagreeable."

In the Kennington days the antipathy of both artists for Impressionism was already clearly marked. But they were nevertheless tempted to study for a time in Paris, its capital. For in Paris art was flourishing with a vitality such as London had not seen since the days of Rossetti. Determined to seek the advice of the object of their greatest reverence, Puvis de Chavannes, they crossed the Channel. They were told that the master would receive them at eight o'clock in the morning. Serious as had been their lives and early their uprising, they were taken a little aback at the suggestion, and actuated partly by excitement at the prospect of seeing a god, partly by fear of oversleeping, they remained up the whole night. With Puvis de Chavannes they were enchan ed. He lavished his kindness upon them, and, perceiving the nature of their gifts, dissuaded them from studying in Paris. " Paris, c'est une foire," he told them. The master was touched by their youth and enthusiasm.

" Quelle charmante jeunesse," he said of them afterwards to a friend.

In 1888 they took from Whistler his house in the Vale, Chelsea. It was in the Vale that they started as creative artists. Although they were still somewhat averse from the society of their fellows, they nevertheless began to associate with other artists. Small gatherings took place in the evenings between the walls upon which the Whistlerian yellow still remained. Presently the yellow, not being sufficiently austere, was replaced by unrelieved-white, but the gatherings continued to flourish. The themes discussed there may have been serious, but their handling was brilliant enough to cause Oscar Wilde to declare : " The Vale is one of the few houses in London where one is never bored."

Sturge Moore, Camille and Lucien Pissaro, John Gray, Rothenstein, and Oscar Wilde, who first brought him there, were all regular visitors at the Vale. Less often came Whistler and Beardsley. With Wilde the friendship of the two artists was particularly warm. Ricketts did the illustrations and designs for Wilde's *Sphinx*, and covers and title-pages for several other of his books. Of the covers perhaps the best is the one for *The Decay of Lying*, the lettering on which is based on Rossetti's handwriting.

Although *Salome* was published in 1893, and *The Sphinx* not until the following year, Ricketts' illustrations were completed before Beardsley's were begun. Beardsley saw the *Sphinx* set one day at the Vale, and they

exercised a considerable influence upon his *Salome*. He himself always disliked *Salome*, and when he had finished his illustrations for it he exclaimed, in the egotistical manner which he at that time affected : " Now I have given distinction to that tedious book. I ought to have done *The Sphinx* and Ricketts *Salome*."

For all his friendship for Ricketts and Shannon, the naturally sociable Wilde could not conceal his amusement at the exclusive atmosphere of the Vale, which was, he used to declare, " too self-contained ". One day he brought there an acquaintance, an admirer of his writings, but destitute of feeling for the graphic arts As soon as he had gone Ricketts turned angrily to Wilde and the following dialogue took place :

Ricketts : Why did you bring this man here ?
Wilde : An obscure worshipper who bowed in the outer court, so I, the god, beckoned him in.
Ricketts : But, Wilde, you said that gods should never leave their temples.
Wilde : You, my dear Ricketts, belong to an older type of deity, who mistake worshippers for food, and when they see one they tear him to pieces.

It was Wilde, who had learned concern for printing and binding from Whistler, who first suggested to Ricketts the idea of designing books. After he had designed and decorated several volumes for John Lane that firm abandoned Ricketts, leaving him in a difficult position. He complained bitterly to Rothenstein, who suggested that he should start a press of his own, which

would enable him to carry out his designs untrammelled by the whims of commercial publishers. Rothenstein then approached his friend, Llewellyn Hacon, who lent Ricketts the thousand pounds with which the Vale Press was started. This was late in 1894.

The following year Ricketts spent in designing type, and between 1895 and 1902 no less than fifty books were published. Every detail of these books was of Ricketts' design. The productions of the Vale Press were to some extent inspired by those of Kelmscott. The work of the great Venetian printers of the fifteenth century, of whom Nicholas Jenson produced the finest type, served as the model both for Morris and for Ricketts. But whereas the Kelmscott books, although they were founded upon a Roman model, tended to be almost gothic in spirit, those published at the Vale were restrained and classical. Morris displays originality and dynamic power; Ricketts, scholarship and taste. A sentence in the *Note* which Morris wrote on his aims in founding his press shows how clearly aware he was of the gothic tendency in his own books. Referring to Jenson's type he says : " . . . I did not copy it servilely ; in fact, my Roman type, especially in the lower case, tends rather more to the gothic than does Jenson's."

Between 1889 and 1897 Ricketts and Shannon had also published five numbers of the finely printed and ornamented quarto magazine, *The Dial*.

During the eighteen-nineties both artists were preparing to paint pictures. They studied the methods of

the old masters, and made numerous sketches which for the most part they destroyed. Within the space of a few years both of them accomplished a rare and surprising feat in achieving a technique so perfectly adapted to their needs that neither has since been impelled perceptibly to change it. Since the vision of both Ricketts and Shannon matured no less rapidly than the technique which served it, it is hardly surprising that their work has changed little in the course of thirty years. Discussing this matter with me Shannon said : " I could take up any picture I had left fifteen or twenty years ago and go on with it with all the original interest. In fact, I have several times done that." And Ricketts : " I have just done some pen and ink drawings in my earliest manner ; and I found myself after a little while completely at home in it."

Certainly if their vision naturally matured rapidly, their way of life, involving as it did an intense and all-engrossing devotion to the arts, was admirably calculated to accelerate the process. The vision of both, while strongly personal, is in no sense profoundly original. The art of Ricketts and Shannon is more than anything else a variation, personal and scholarly and in exquisite taste, of certain arts of the past. Ricketts' own attitude towards the question of such variation of the art of the past is, I gather, that close imitation by any but contemporaries is all but impossible. A Lancret, he holds, working in the studio of a Watteau, might successfully imitate him, but if a twentieth century artist attempted

to do so, he would inevitably bring some new factor into the work which would entirely change its nature.

Perhaps the easiest way of defining in negative terms the nature of the vision of Ricketts and Shannon, is to say that it is the antithesis of the Impressionist. Their art is, before anything else, a contradiction of the Impressionist attempt to realise vision by an immediate process. The artistic forces which early helped to form their outlook were numerous. First and foremost among them were the great Italian masters, whose methods Ricketts and Shannon studied considerably more closely than did the Pre-Raphaelites. Of the Italians the Venetians affected Shannon the more powerfully. In his painting, *Tibullus in the House of Delia*, this influence appears most clearly. Next in importance were the Pre-Raphaelites. It is recorded of Ricketts that he was so greatly moved by the Rossetti memorial exhibition that, in the manner of an earlier generation, he burst into tears. " Nothing that Ricketts ever did," said Sargent, " could have been done without Rossetti." For Burne-Jones also he had the deepest admiration. The influence of Madox Brown did not touch Ricketts, but it is perceptible in some of the earlier work of Shannon, whom he knew and encouraged. (" A charming boy, Charlie Shannon," he remarked to Laurence Housman, " but he talks so much and asks so many questions that one does not know what one thinks or what one does not think.") A more important influence, and one common to both, was that of Dürer. His works they studied in an excellent and

voluminous German history of wood-engraving which
appeared while they were students. Lastly there were
two prose works : Reynolds' *Discourses* and Eastlake's
*Materials for a History of Oil-Painting.*

Their study of the methods of the old masters, whether
it was direct, or in the painting of their modern followers,
or in books, led Ricketts and Shannon to reject not only
the Impressionist ideal of realising vision by a direct and
immediate process, but practically the whole of modern
technique. This they did on the ground that there are
certain important colours which cannot be obtained by
direct painting, but only by glazing ; and that much
modern direct painting is so faulty as to be liable to very
rapid deterioration. Both artists have therefore returned
as nearly as possible to the technical methods of the old
masters.

Shannon has consistently retained much of the vision
of the Italians, but Ricketts has been profoundly affected
by an influence which I have not as yet mentioned, since
it is so inconsistent with all the others. That is the
painting of Delacroix. The effect of it upon both the
colour and composition of a number of Ricketts' pictures
is very evident. Many artists have admirations which are
greatly at variance with their own work. Ricketts him-
self told me of Toulouse-Lautrec's ardent admiration for
the painting of both Burne-Jones and Watts, and how
one day, when the Frenchman and himself were visiting
a Royal Academy exhibition in which Watts's *Birth of
Eve* had been hung in a good, but not the best place,

Lautrec burst out in fury at the slight which he said had been put upon a great picture. Toulouse-Lautrec could admire the painting of Burne-Jones and Watts without his own being in any way affected by it; for life was the mainspring of his inspiration. But for Ricketts, a born eclectic, such platonic admirations are not enough. The sources of his own inspiration are rather in art than in life. Taste, therefore, means so much to him that he needs must give it concrete and immediate expression.

The sources of Shannon's inspiration are hardly less purely artistic, and his compositions are carried out with little reference to life. After envisaging a composition fairly completely he makes, without models, a slight preliminary study, very often in lithographic chalk. Many of his lithographs are simply first studies for oil-paintings. When the composition has been transferred to the canvas, models are sometimes used, but usually only for details such as heads, hands, and feet. The two conflicting motives which run through all his friend's work were clearly seen by Ricketts when he wrote: " L'amour du luxe et de la richesse décorative se corrige chez lui par une réticence qui se ressent de la fréquentation des maîtres austères du passé."[1]

Besides his painting, Shannon has done ninety-six lithographs and a number of woodcuts. Thornley's folio of copies of Degas' pastels in lithograph, which Shannon saw in 1887, first suggested to him the use of this medium.

[1] *L'Art et les Artistes.* February, 1910.

# Ricketts and Shannon

Ricketts' versatility is exceptional. In addition to painting many pictures in oils, decorating and illustrating many books, and founding and managing the Vale Press, he has modelled nearly thirty statuettes, written largely, and not only designed the scenery and costumes for many theatrical productions, but carried out a great part of the work with his own hands. Lastly, together with Shannon, he has amassed a superb collection of objects of art, the foundation stone of which was laid at the Leighton sale.

In almost everything which these two artists have achieved in their widely different ways, may be seen the same remoteness from real life, the same fine taste, and the same conscientious workmanship. I think also that the memory of their personalities will survive : of Shannon, tall, reticent, and serene, whose face yet just perceptibly reflects something of the conflict between the love of the voluptuous and the love of the austere which is so clearly marked in his painting : of Ricketts in his characteristic posture, with head thrust forward, brows drawn down over the intense and eager eyes ; always talking rapidly and well, enthralled by every intellectual movement, every manifestation of the artistic spirit.

Among those whose work has been consistently influenced by them, the most important is Thomas Sturge Moore. This fine wood-engraver and poet met Shannon in 1885, when he himself was only fifteen years old, and was encouraged by him to attend the same school at which he and Ricketts were already studying. He was a

leading member of the small group of Lambeth students under the leadership of Ricketts and Shannon, and also of the later and larger one whose headquarters was the Vale. It is characteristic of the present time that an artist of real imagination and solid technique should remain entirely unrecognised because his work is lacking in the emphatic qualities which the modern public has come to demand. But the public of his youth was even less enlightened. He told me that he once gained at an art school a prize of thirty shillings for modelling, to be spent on buying books. Moore insisted upon being allowed to acquire instead two Hok'sai prints, which Ricketts and Shannon coveted, but could not afford. The headmaster was so contemptuous of the prize which the young student had insisted upon receiving, and so ashamed of what the audience would think of an art school which gave such wretched gifts, that at the prize-giving ceremony he insisted upon temporarily substituting a book in the place of the despised Hok'sais.

## Chapter Ten

### Rothenstein

THE laſt decade of the nineteenth century was for Rothenſtein an adventure which involved him suddenly and completely. For the time he appeared to be as charaĉteriſtic a produĉt of the period as Beardsley himself. Yet the *rôle* which he played in the 'nineties tallied little with the nature of the player. It is not implied that he consciously played a part. But circumſtances gave him an opportunity which the adventurous spirit of extreme youth, which did not know itself, could not resiſt, of engaging in an adventure little in keeping with what was moſt fundamental in his charaĉter.

There is no reason why he should have resiſted such an opportunity. If the adventure did harm in that it delayed by several years the artiſt's discovery of the true nature of his own impulses and talents, it proved, on the other hand, an intelleĉtual ſtimulus potent and laſting. Not only did the part which he played in the 'nineties bear little relation to the essentials of his own nature, but also to the life which he led both before and after that time. He had no natural anti-classical bias, ſtill less the deeply rooted antipathy for modern

civilisation. I believe that his environment during the seventeen years which elapsed between his birth and his admission into Julien's Academy in Paris accounted largely for the absence of an antipathy which formed so integral a part of the artistic mind of the 'nineties.

William Rothenstein was born in Bradford, Yorkshire, on the 29th of January, 1872, the second son of Moritz Rothenstein, a wealthy and cultivated cloth merchant. That is to say that he came neither from the aristocracy, which viewed industrialism as an ugly force which was rapidly destroying its leisure and its privileges, nor from the labouring class which industrialism had enslaved, but from the class which had made it and whom it, in turn, had made. The Rothensteins came originally from Gröhnde, near Hamlin, where they had farmed for many generations. After having improved their position by judicious marriage, they came first to England early in the nineteenth century, soon becoming part of the solid and prosperous upper middle class. As a child I used to visit my grandfather's house, and the impression which remains is of order and serenity, of furniture darkly shining, of ugly but substantial bookshelves with endless rows of collected editions, Thackeray, Walter Scott, Goethe; of napkins gleaming white, heavy silver, claret in decanters; and over all the clinging odour of cigar smoke.

Every day of the first sixteen years of his life William Rothenstein saw the best side of industrial and commercial society—and found it intolerable. But

intolerable as he found it for himself, the industrial world did not appear wholly evil to him. The spirit of powerful optimism which prevailed in the great commercial city, its profound belief in the ability of mankind to control its own destiny; the dignity and probity and austerity of the leaders of its society; the friendly and personal relations which existed between the members of his family and the employees of their big warehouse; all these things had their effect upon him. Although there was much to give him a sense of the fineness that there was in such a state of society, he himself found it insufferable from the first. He realised very early that he had to be an artist, and that for an artist there was no place in a society so confined and so rigid.

And so its interests were never his interests. All his youthful pursuits were in the nature of escapes from his environment, escapes into the past and into the open. He sought satisfaction for his love of the past partly by ransacking all the curiosity shops, and marring the Victorian perfection of his parents' home by introducing long-handled swords from Japan, dusty volumes of Restoration comedies, seared parchments, and cracked pots; but above all, he sought satisfaction by reading. When he was neither reading nor drawing nor ransacking curiosity shops, he was wandering on the moors. The northern bleakness, the hardness of outline of these stern moors had a profound and lasting effect upon his temperament and consequently, his vision. There was even in these early days something austere and uncom-

promising in him which responded to the grim qualities in the moors, something which they in their turn ſtrengthened in him. But during the eighteen-nineties all this lay hidden. A favoured haunt was the sombre reƈtory at Haworth, where the Brontë family, which he idolised, had lived and written.

The religious temper of the Bradford of those times was evangelical. He, on the other hand, was in passionate sympathy with those who, like Newman, Pusey, and Keble, tried to bring back into England something of the spirit of mediæval Chriſtianity. This enthusiasm died when he left Bradford, and religious intereſt was not born again in him until many years later, when it appeared in a very different form.

I have mentioned these faƈts of his childhood as I believe them to have exercised an influence of the greateſt importance upon his development ; an influence far more laſting than the exciting period upon which he direƈtly afterwards embarked.

At the age of sixteen he left Bradford for good, and went to London to become a pupil of Alphonse Legros, who was then Professor at the Slade School. Legros was a pupil of Ingres, an excellent draughtsman, an indifferent teacher, and the wit who replied when asked by a Frenchman what he had gained by becoming a British subjeƈt, " D'abord, j'ai gagné la bataille de Waterloo."

After spending a year at the Slade he moved, in 1889, to Paris, where he entered Julien's Academy and ſtudied

# Rothenstein

under Benjamin Conſtant and Jules Lefèbre. He was confided by his parents to the care of his attractive but worldly uncle, Leopold Rothenſtein, who had lived in Paris for many years.

The feet of William Rothenſtein no sooner touched the pavement of the Boulevards than he underwent a change. He was entering upon a decade during which he was to live more intensely and yet less characteriſtically than at any other period of his life. His childish solemnity and auſterity fell away from him and religion no longer intereſted him. From the very day of his arrival in Paris the *tempo* of his life seemed to change. On his firſt afternoon he watched a regiment of cuirassiers charge a mob of rioters. That night he could not sleep because of the knowledge that he was in the city of Balzac, Saint Louis, Napoleon, Delacroix.

Within a few months his gifts as a draughtsman, precocious wit, and foppish attire had made him something of a celebrity. Degas and Puvis de Chavannes and Whiſtler had spoken warmly of his work. Edmond de Goncourt and Zola and Alphonse Daudet invited him conſtantly to their houses. He became a close friend of Rodin, Verlaine, and Toulouse-Lautrec. Oscar Wilde called upon him, dubbed him " a golden Buddha " (he was golden indeed, being convalescent from typhoid fever), and suggeſted that Toulouse-Lautrec's minute caricature of him should be bought for the National Portrait Gallery by a farthing levy upon the English nation. He saw much also of Stephane Mallarmé,

Anatole France, Huysmans, and Renoir, whom he once encountered in circumstances which seem to me so significant as to be worth mentioning, in view of the enormous prices which his work now commands. Renoir was holding an exhibition. Rothenstein entered the gallery, which was empty save for a solitary unhappy figure crouched with bowed head in a chair. The dejected figure raised its head, and Rothenstein recognised Renoir. He went up to the master and told him shyly (for he was then not much more than seventeen) of the deep veneration in which he held his work. Renoir, touched by his sincerity, thanked him, saying that if he painted according to the dictates of his conscience he must not expect recognition in his own lifetime.

After four years, in 1893, he returned to England. His Parisian life had taught him much, but it had also withheld something of the first importance. That is to say that his drawing, while it was often marked by brilliance and force, was without the element of academic perfection which was so necessary to the expression of his real vision, from which he had departed, and to which he was destined to return. Had it been his fate to follow strictly in the impressionist tradition in which he had started, this defect would not have been so grave. But to give adequate expression to that austere and uncompromising view of life which he gradually evolved, something of academic perfection was essential. Nor in this respect was his painting any better. Because of its

# Rothenstein

ſtyle and brilliance, and the dramatic sense which it clearly displayed, his work was at that time universally overpraised and its obvious defects were overlooked.

This facile success was much to the artiſt's subsequent disadvantage. On the other hand, during his years in Paris he acquired worldly experience, perfect knowledge of French, and considerable acquaintance with French literature. More important than all this, he was privileged to meet and enjoy the friendship of many of the keeneſt intellects and nobleſt characters in Europe.

When he returned to England, he was yet ignorant of the true nature of his own vision and of his shortcomings, since the accomplishment which he already had at his command was well adapted for the kind of work which then engaged him. In 1895 he settled permanently in London, taking a ſtudio at 53 Glebe Place, Chelsea. In the summer of 1893 he went to Oxford to do the series of portraits in lithograph which were published under the title of *Oxford Characters*. These drawings reveal the same qualities which characterised his work in Paris. The dashing technique, the vigorous ſtyle, the ſtrong sense of character are all there. But only in some of the portraits of the more ancient among the dons is there a trace of the reſtraint and auſterity of the future. At Oxford he remained lrregularly for a year, living the life of an undergraduate, ſtaying firſt at one college, then at another, but never attaching himself officially to the university. His firſt hoſt was Herbert Fisher,

who had shared the same *pension* in the Rue de Beaune, in Paris, and was now become a Fellow of New College.

At this time he was admitted to the friendship of Walter Pater, who delighted in questioning him continually about Mallarmé and Huysmans and many other Frenchmen about whom he was insatiably curious. Rothenstein's portrait of him he detested, complaining bitterly to his sister that "That young man has made me look like a Barbary ape." After a moment's silence he burst out again, in anger just tinged with misgiving: "*Do* I look like a Barbary ape ? "

During the period which intervened between Rothenstein's departure from Paris and his establishment in London two projects were fulfilled. In the company of R. B. Cunninghame Graham, Rothenstein travelled through Spain, crossed over to Africa, and then rode on horseback across Morocco as far as Wazzan and back. In one town through which they passed the prisoners were still kept in iron cages by the side of the road. These unfortunate beings depended for food and drink entirely upon the charity of passers-by.

When he settled finally in Glebe Place, he decided in view of the encouragement he had received regarding *Oxford Characters*, (there had been opinions less unfavourable than Pater's) to set to work upon a new book of a similar kind.

Meanwhile his association with Whistler, which had started in Paris, became closer, and the influence of that

PLATE VI

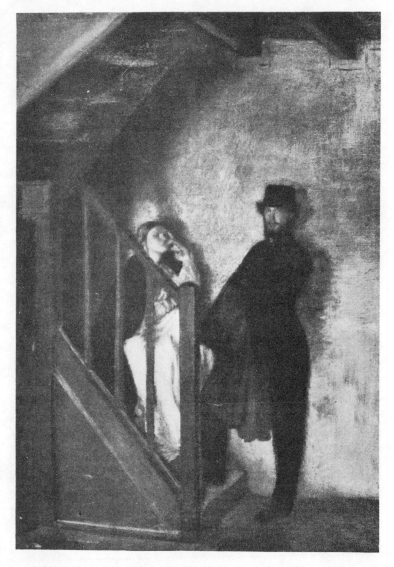

THE DOLLS' HOUSE

*William Rothenstein*

*By courtesy of the National Gallery, Millbank*

[ face p. 198

master upon his work consequently greater. For so powerful and so dazzling was Whistler as a personality at that time that for a young artist to see much of him was to be influenced by him. In Rothenstein's case this had a twofold result. His painting became still lower in tone and less distinct in outline than it already was; and he himself was considered to have thrown in his lot with the impressionists. The whistlerian influence had the effect of still further retarding Rothenstein's discovery of the manner best suited to the expression of his own vision.

How wide was the gulf which separated the academic artists from the Impressionists with whom he was identified, and how deep was the disapproval with which the French innovators were regarded, is illustrated by the circumstances of his encounter with Holman Hunt. It had been arranged that Rothenstein should make a lithograph drawing of the painter of *The Awakened Conscience*. He arrived at the appointed hour. It was immediately evident that something had occurred which had altogether changed Hunt's attitude towards the projected portrait. A servant came down and made vague excuses. Presently Hunt himself arrived, in a state of the greatest agitation. Rothenstein began to take out some lithographic chalk and paper, at the sight of which Hunt protested. " But you can't take a photograph with those materials," he said. Rothenstein protested that he was an artist and not a photographer, and referred to Hunt's cordial permission to draw him.

"No," said Hunt, "I underſtood that you were to photograph me. To make a drawing is quite a different thing—quite a different thing, and something which I cannot allow."

It was some weeks before the cause of this singular conduct was discovered. In the interval between the arrangement for the sitting and the sitting itself a friend of Holman Hunt's had informed him that he was to be drawn by a follower of Whiſtler's, an impressioniſt, no less—a piece of news which so alarmed him that he took refuge in somewhat transparent subterfuge.

For a few years after his return from Paris Rothenſtein continued to live and work with fiery intensity under the influence of Whiſtler, submitting enthusiaſtically to that maſter's doctrine of "art for art's sake", and his foppish and affected code of conduct. But how little there was of blind submission on the part of Rothenſtein in his relations with Whiſtler is revealed in their ſtormy and pugnacious correspondence.

Long before the passing of the century there were already signs of a change in Rothenſtein's outlook, which was at once reflected in both his painting and his drawing. The whiſtlerian influence over his painting began to wane. The exotic element disappeared, the decorative intereſt became smaller, and a new motive, emotional rather than æſthetic, appeared in their place. The mood passed which had produced ſtylised compositions of gentlemen in silk hats and frock-coats and artificial ladies with an air of 1830 romanticism, of the

type of the *Two Ladies*, published in *The Savoy* in 1896, *L'homme qui sort* (a portrait of Conder), *A Portrait of Toft*, and *Souvenir of Scarborough*, which influenced Beardsley so strongly.[1]

The emotional phase which succeeded was the first step towards a view of life and of art that was for Rothenstein something entirely new. From the moment at which he ceased to be fascinated by the pure æstheticism of Whistler, he has evolved steadily towards an art which has its roots deep in the soil of the visible world. His interest in human existence has always been too passionate for him to acquiesce for long in a system of æsthetics which attempts to separate art from human emotion. How rapid was the change from one temper to the other may be judged from a comparison between the pictures first mentioned and *Vézélay Cathedral*, *The Doll's House*, *The Browning Readers*, and *The Quarry*. The new and graver temper found even more articulate expression in a short study of Goya which he published in 1900. In this book (the first, I believe, to appear on Goya in the English language) he says :

> For whatever reasons men may give for their admiration of masterpieces, it is in reality the probity and intensity with which the master has carried out his work, by which they are dominated;

---

[1] Beardsley's debt to Rothenstein was emphasised by Robert Ross in the original draft of his urbane *Eulogy of Aubrey Beardsley*, which served as a preface to the sumptuous edition of Ben Jonson's *Volpone : or the Foxe*, illustrated by Beardsley and published by Smithers. Rothenstein had given forceful expression to his disapproval of the nature of Smithers' influence upon Beardsley. This denunciation so angered Smithers that he deleted the entire paragraph relating to Beardsley's admiration for Rothenstein. Ross himself related the incident verbally upon several occasions, and once in a letter.

and it is his method of overcoming difficulties, not of evading them, which gives ſtyle, breadth and becoming myſtery to his execution.

We have here an exaſt ſtatement of the ideal which the artiſt had set before him, and his renunciation of his own earlier ſtyle, with its dashing attack and rather facile charm.

In that they rejeſted the classic idea more decisively than any of their contemporaries, the artiſts of the 'nineties were in harmony with the underlying spirit of their own time. Therefore Rothenſtein, although one of the moſt classic among romantic artiſts, could have no quarrel with them, since his own reaſtions also were in accord with the times. But where the men of the 'nineties rejeſted that which dominated and typified the age, the induſtrial order of society, they were in discord with the spirit of the age. The proteſt of the men of the 'nineties was of a kind entirely different from that of the Catholic Church, whose aim muſt inevitably be so to change society in order that the individual may be wholly responsible. The men of the 'nineties, being artiſts, could only rejeſt and escape from an order of things which it was outside their funſtion to attempt to change.

A deep-seated belief in the attempt to make the moſt of circumſtances, rather than any particular regard for the uglieſt of all social organisations, has prevented Rothenſtein from insulating himself permanently, as they did, from it. How earneſtly he has, on the contrary, sought to decentralise the artiſtic life of England and to

bring it into relation with industry and civic life, may be seen from his numerous pamphlets. During the intense and vivid years of the early 'nineties, he was subject to an influence alien to his real nature. Since emancipating himself from it, his work has passed through widely differing periods. He has been occupied in turn with series of paintings of London interiors, Jewish refugees from Russia; landscapes, mostly of northern France and western England; Indian temples; soldiers and ruins in France and Belgium. As a draughtsman he has devoted himself to making a vast record of those of his contemporaries whose achievements, character, or appearance have compelled his admiration.

In each greatly differing activity and period he has sought, and it seems to me that he has found, a means of expressing with strength and intensity, emotion that is passionate, yet sternly controlled.

# Chapter Eleven

## *Max*

SOME of the immediate yet secondary motives which cause
the artist to pursue his calling, as, for example, the
desire for fame, for wealth, for power, have been men-
tioned in the chapter here devoted to Steer. Such
motives are clear enough. Unlike the majority of
writers who have dealt with the problem, I believe that
the fundamental motive to artistic creation is hardly
less clear. In one sense such motives are impossible to
reveal, for the nature of the impulse to live remains the
least soluble, and most alluring of mysteries. But granted
the existence of this force, it is a matter of no great
difficulty to see, and to set apart, those manifestations
of it which are the foundation upon which art is built.
There seem to me to be two such manifestations : one
is the desire to communicate to others any passionately
felt emotion. The other is the protest against the
anonymity and disorder of the world, which results in an
attempt to create something which shall be at once
representative of what is profoundest and most personal
in the artist, and more permanent than he himself. The
artist sees a world, which, if as we are told, it was made

204

for man, remains curiously invisible to the greater part of humanity.  And when he sees it, he feels its qualities, its beauty, its ugliness, its majesty and power, and desires passionately to make what is visible to him visible also to his fellows.  How clearly he can do so is shown by the fact that most people, when they look at the visible world, regard it with the aid of an artistic convention. This is the basis for Wilde's paradoxical contention that nature copies art.  Man being essentially conservative, prefers a convention that is old.  The French public of the eighteen-sixties did not hate and despise the landscapes of the impressionists because they were unlike nature, but because they were unlike the conventional presentations of it to which they were accustomed.  But the artist, because of his instinctive protest against anonymity and chaos, presents a view of the world fundamentally personal and orderly.  For even the least disciplined works of art possess, from the human standpoint, an element of order entirely absent from nature. " It is not enough for me to be conscious of what is in me ; others must know it, too ! " exclaims Prince Andrey in *War and Peace*.  Prince Andrey is not a practising artist, yet when he is moved by the ecstasy of the spring and by the contemplation of the most solemn memories of his life, Tolstoy makes him give utterance, simply and directly, to the deepest impulse by which the artist is inspired.

Of all English artists Max Beerbohm has fulfilled most completely Prince Andrey's aspiration.  So completely,

indeed, has he done so that he has left little to be said by the critic. He has reached an intimate under-standing of his own nature, evolved an attitude of singular fascination and unity towards life, brought two mediums to so high a pitch of perfection that to all who look at his caricatures or read his essays, his personality is fully revealed : that is his achievement. Max has done more than Prince Andrey hoped to do ; for of Max it may truly be said that he is conscious of *all* that is in him, and that he has expressed it so completely that others also may know all that is in him. It is the fate of this most perfect of self-portraits to fade somewhat, because for the most part the painter has depicted not subjects of eternal human interest, but those dependent for their wit and humour upon transient situations. It is therefore for our eyes that its colours shine most brightly. When a few generations shall have passed away, and the subjects with which Max has dealt will be known no longer to those who look, some of the brilliance will have gone from the portrait. But not much of it. After the subtleties which only we can fully comprehend have lost their meaning, the fading process will become infinitely slow.

Rarely and slightly as Max touches upon the great problems which have everlastingly fascinated and troubled humanity, his work does possess certain qualities which will be of interest so long as interest in character remains, qualities in no way dependent upon the spectator's previous knowledge of the subject portrayed.

# Max

For besides the supreme self-portrait which his work constitutes as a whole, Max also has the power of presenting character, in one sense, in a manner unrivalled by any English caricaturist. His power of portraying types of character, old drunkards, burly farmers, jolly squires, young ladies of fashion and so on, falls short of Rowlandson's, of Keene's, or of Cruikshank's. But in the depth of his understanding and the subtlety of his presentation of the character of given individuals he is immeasurably the superior of any of them. He is able to give, in the best of his caricatures, aided by the written description or dialogue which almost invariably accompanies them, a complete impression of some man's character, appearance, aims, mannerisms, of everything, in fact, about him. In the admirable series *The Old and Young Self*, in which he shows a number of middle-aged men confronted with themselves as youths, this capacity is as clearly manifest as anywhere. Not only is H. G. Wells's career, philosophy, and characteristic attitute towards life summed up with an accuracy and insight which can hardly fail to delight and amaze those who may happen to be familiar with the writings or personality of that prophet ; but a character is presented with such wit and consistency as to captivate even a spectator ignorant of the identity of the subject.

Subtle and comprehensive as is the picture he has painted of the social life of his own time, the work in which he reveals his greatest powers is an historical reconstruction. In *Rossetti and His Circle*, Max not only

exhibits his accustomed wit and insight and an enhanced beauty of technique, but a power of sustained characterisation, and a capacity to present an entire world other than his own, neither of which had been apparent before. The sombre and enthusiastic recluse, the enigmatic nature whose melancholy and uneven genius held his intimates enthralled, is presented with a tenderness rarely found among satirists. The very essence of Rossetti's character, the nature of his relations with his family and friends, and above all the atmosphere which pervaded the whole circle, have been perceived with a subtlety and set down with a precision and beauty which gives the series a place among the rarest works of satire. The grotesque element typical of the artist's earlier work is hardly present in these drawings. For Max, like most other caricaturists, has tended, after reaching maturity, to obtain his effects by variation within ever-narrowing limits, to become, in other words, more and more of a realist. Here also there is a lessening in vigour and boldness of line ; but there has come in its place an excellence of composition and a delicacy of touch.

At no other artist of the 'nineties save Beardsley has the accusation of inability to draw been so constantly levelled. The fact is that Max, having had no academic training as a draughtsman, has laboriously taught himself. Mistakes of every kind abound in his early work, but as the years have passed such faults have grown rarer. Compare for example the *George IV* of 1894 with *Rossetti's Courtship. Chatham Place, 1850-1860,* of 1922.

PLATE VII

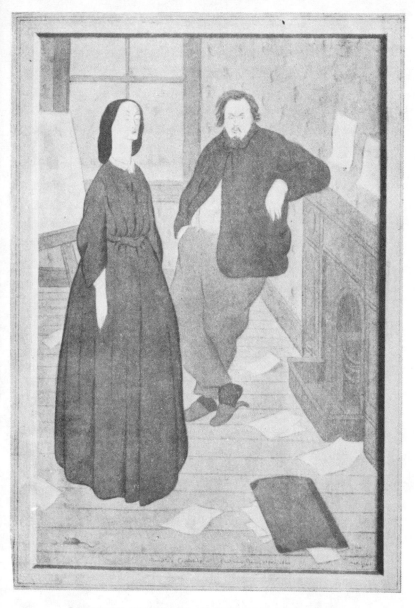

ROSSETTI'S COURTSHIP. CHATHAM PLACE, 1850—1860

*Max Beerbohm*

*By courtesy of Mr. Hugh Walpole*

*face p. 208*

# *Max*

The draughtsmanship of the earlier work (which has always been a popular one) is ſtrikingly incompetent. The lines round the lower part of the monarch's face intended to signify the multiplicity of his chins are entirely lacking in significance ; while his right arm could hardly have been portrayed more feebly. The drawing is saved by the excellent placing of the figure upon the paper. On the other hand the draughtsmanship of the later work leaves nothing to be desired : that is to say, it gives adequate expression to the idea in the artiſt's mind. I know of no other picture of any kind in which the relationship between two people has been portrayed with so much tenderness and underſtanding. There can be little wrong with a draughtsmanship which is able to give life and clarity to a concept so subtle. In as far as technique may be considered apart from the spirit which informs it, Max's draughtsmanship may be said to be without either the sure ſtrength of Keene's or the vitality of Rowlandson's, or the character of Cruikshank's. But if technique is considered, as it appears to me that it should be, as a means of expression ; and considered excellent solely in proportion as it is efficacious in conveying the artiſt's meaning, then a great part of Max's technique may be considered admirable, since it gives full expression to one of the wittieſt, keeneſt, moſt delicate minds of its generation.

In several of the preceding ſtudies I have attempted to indicate something of the artiſt's character. This, in the case of Max Beerbohm I shall not do, since he has

# *Max*

himself given in his own works the moſt complete and
precise self-portrait possible. It is sufficient to say
one thing: that to know him is, before everything
else, to realise how perfectly the man is reflected in
the works.

# INDEX

211

# Index

# Index

# Index

# Index

215

# Index